FROM SEEING TO SHOWING

The making of twenty black and white

GEORGE E. TODD

ARGENTUM

First published 2001 by Argentum, an imprint of
Aurum Press Ltd, 25 Bedford Avenue, London, WC1B 3AT.

A catalogue record for this book is available
from the British Library.

ISBN 1 902538 11 0

Origination - Garnet Publishing.
Printed in Singapore by Imago.

None of the secrets of success
will work unless you do

(Chinese Fortune Cookie)

Acknowledgements

My sincere thanks are offered to friends in the photo-industry: Agfa,
Amaloco, Hasselblad, Heliopan, Kodak, Polaroid, Dr. Richard Ross and
to many others, especially Wilhelm Heiland. Above all, a special word of
gratitude goes to Mike Gristwood, Ilford Imaging UK Ltd, for his patience
and liberal technical guidance – critical help that made this text more
authoritative, and accurate. Thanks are also extended to Günther
Neugebauer and Matthias Schneege of Ilford Imaging GmbH Germany,
for their generous support in both words and deed. Matthias also read
an initial draft of this book, as did Dr. Peter Baumbach of Rodenstock
Optische Werke, Munich, photographer-author Dieter Beckhusen, and
Brad Lentz; their encouragement was a great boost. Finally, thanks to
Eddie Ephraums, photographer, author and publisher, in whose hands
this became a better book.

Dedication

To my wife Patricia;
her enthusiasm and perennial *wanderlust* leads
us both to such stimulating, far away places.

CONTENTS

FOREWORD

After decades of photographing almost anything that came my way in colour, and exhibiting the results on incomparable Cibachrome materials, I decided in the mid-Eighties it was time to return to the monochrome roots of photo-expression. It was a move triggered in part by a widespread and regrettable fall in the general public's respect for photography as a result of ever-cheaper mass-produced C-prints. I embarked on a self-imposed refresher course in which experience was to be my best teacher, backed by all the standard reference books my pocket money would allow.

Monochrome photography was no new domain for me. During the 1950s and early Sixties, I had used relatively primitive cameras to make pictures for engine-tuning and travel articles published in motorcycle magazines. High speed two-strokes, combustion chamber design and exhaust pipe dynamics were more attractive to me than the mixing of developers, or black and white printing. This was left to a local photo studio, one of the old 'D & P' mainstays of the day. But an embryonic interest was there, fuelled by ever-improving results and better cameras.

Moving job and home to Bavaria in 1972 led to a rekindling of artistic interests. Living in sight of the Alps, I began taking close-up pictures of alpine flowers to augment my wife's botanical activities. Then in 1975, Victor Hasselblad's famous box-shaped camera came into my life via a scientific programme in which five Hasselblads were launched on a high altitude research rocket for an Earth Resources photography project. Unfortunately, the rocket's main stage malfunctioned and the resulting hole in the Swedish landscape contained not only unburned fuel, but also cameras shattered into more parts than before assembly

in Göteborg! That brief encounter with the most famous medium-format camera on Earth, or in space, changed my photography orbit for good. Twenty-five years later, catching the myriad shades of light is still a burning preoccupation.

Like some of the images depicted within, the offer to write a book about some of my photographs came to me out of the blue. With an archive of nearly 1000 enlarged and exhibited pictures – and another 149,000 images waiting in the files – the choice of which to use was not easy. I decided on a group of pictures that would illustrate certain workshop themes, a kind of forum presentation peppered with technical data and spiced by a few stories.

Preparing this book was a highly instructive undertaking, giving me new insight into each negative. I rediscovered the difficulties and nuances of printing – approaching each task as if for the first time, without reference to previous data. It has also been a sentimental journey, recalling the events or persons involved; fleeting moments locked in silver. What follows relates how I found these motifs and coped with the various problems, not only in the making of an image but also in producing a print for an exhibition.

Regardless of how hard won, knowledge in any field is a precious thing; it should be handed on to young and old alike – something I enjoy doing at every opportunity. Similarly, the pages of my notebooks are always open to other eyes and in my photo-workshops no question goes unanswered, even when it is necessary to research it first for my own enlightenment. I am thus grateful to the publishers for this chance to share a few favourite pictures with my readers, and perhaps inspire them to look and see beyond the prosaic to the evocative world of monochrome photography.

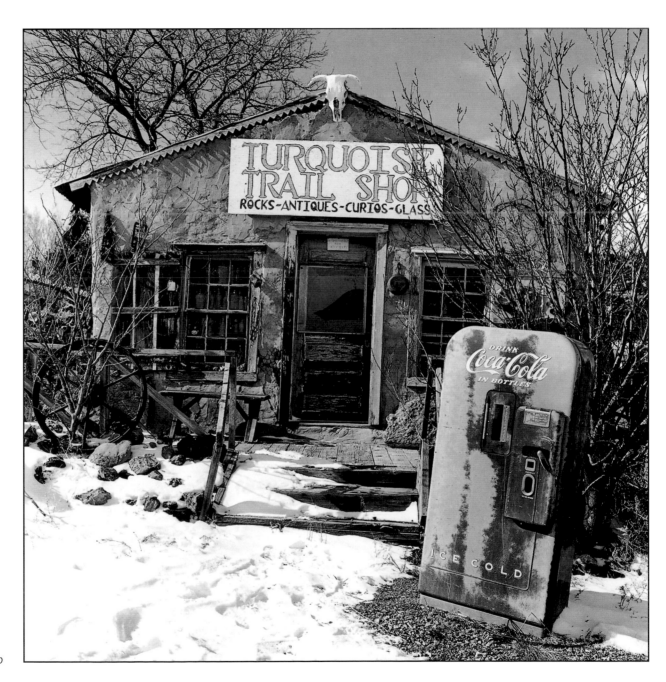

Turquoise Trail Shop

A ONE-SECOND SNAPSHOT ...

Old Prague 1992

Perhaps a hand-held 'snapshot' is not the right image with which to start a book on the finer points of black and white photography. Nevertheless, it is an image that took just a few seconds to make. It was seen in old Prague city during a four-day package tour to enjoy the music that Mozart wrote there, and to visit sights familiar to me from books like those by Josef Sudek. His large-format panorama photographs of that pre-war city earned him the name Poet of Prague. It is incredible how he operated that huge camera with only one arm. I heard a story about a man in Wenceslaus Square looking, as he thought, at a large sack filled with potatoes – until the heaped form wriggled and out came Sudek; he had been loading sheet film cassettes!

Knowing it was going to be a concentrated 'culture trip', I opted to leave all the heavy photographic gear at home, taking instead a Plaubel Makina 67 camera. It sits comfortably in the hand and is ideal for good, sharp snapshots – provided short exposures (½₅₀ second) are possible. The 6 x 7 cm (2 ¼ x 2 ¾ inch) medium format is often called 'Ideal', though I believe this tag really refers to a vintage Linhof camera also using roll film but with a slightly larger image frame.

At some point during a conducted walk through the old town, this rather gloomy arcade beckoned tantalisingly to my lens. Curving out of sight, it seemed to epitomise the eternal question: What lies ahead, just around the corner?

For the low available light, the Plaubel's built-in light meter reckoned one second at f/11 for a decent depth of focus; but hand-held, without a tripod? Ridiculous! Even with such an easy to hold, wide-angled camera like the Plaubel a one second shot was well beyond the rule of thumb: 'handheld shutter speeds should be no longer than the lens focal length' (e.g. 1/60th second with a standard 50mm lens). On the other hand, a bean bag might have helped, but this too was at home with the other hardware.

When the only option is a snapshot, a steady hand is very useful. During my war service, I learned to shoot a 'possible' at 100 yards on the rifle range, a skill that led me to take up the sport a few years later.

In competition shooting, breathing control is all important – and a real asset,

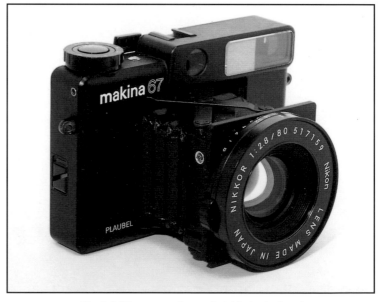

Plaubel 67 camera; sits comfortably in the hand

when confronted with a motif like this. Pressing the camera firmly against the nearest arch, I breathed out and gently squeezed the button, doing this three times to make sure that at least one image would be sharp.

Just as the shutter zizzed for the third time, somebody's foot appeared around the farthest corner, the sort of thing Henri Cartier-Bresson, 'Grand Master of the Decisive Moment', was much better at anticipating – or maybe had set up?

The classic bean bag I had wished for (see illustrations p. 10) is worth more than its weight in beans for tricky jobs like these. It moulds to any form on top or underneath, firmly supporting the camera as well as any tripod could. In public buildings such as a cathedral, where tripods are not allowed but available light

Negative Data

Image: Old Prague 1992
Format: 6 x 7 cm
Camera: Plaubel Makina 67
Lens: 80 mm Nikkor
Film: Ilford FP4
Developer: Ilford Perceptol

Print Data

Enlarger: D2 Aristo cold light
Lens: Rodenstock 105 mm APO
Fine print: Agfa MCC 111
Developer: Amaloco 6006 1:7
Toner: Kodak Selenium 1:20
Mounted size: 13 x 15½ inches

photography is possible, a bean bag placed on a pew or pressed against a wall or column makes the task easier. For close-up photographs of alpine flowers, a bean bag on the rocky ground serves not only as a support, but also avoids damaging the camera body or lens barrel. Moreover, when using a camera without a mirror pre-release function, the soft leather cushion may help minimise vibrations from the reflex mirror's action.

When I showed my local photo-dealer a prototype of Todd's 'T-Bag', he saw the potential and immediately started a production run of 100 pieces. They sold like hot cakes at the next wild-life photographers jamboree. Incidentally, if you get lost in a desert for a few days, survival might be ensured with the bag's half kilo of white beans, though they may be a bit chewy without water!

Old Prague 1992 was exposed on FP4 and developed the same day in downtown Prague, in a smart three-star hotel built in the Sixties for the Communist Party Genossen. Being late November, it was soon dark enough for me to hide in a wardrobe to load the film into a Paterson Universal tank. The toilet served as yet another temporary lab to mix and pour my favourite developer, Perceptol, at 1:1 ½ (see Chapter 18).

Back home, I found that the first negative was the best, and just a touch sharper than the other two. It is an easy image to print on fibre base papers ranging from Agfa MCC or Forte's heavyweight warm-toned materials, to Ilford's MGIV, the new Warm Tone version. Irrespective of the kind of photo paper used, the result (for me, at least) is a gentle picture of an older world disappearing faster than ever before.

This event in Prague was contrary to all I've ever said about photographing in groups, though in this case the other 28 people – mostly oldies – had wandered on toward the next point of interest.

While running photo-workshops in far away places like the Agean islands, watching the participants click away at something, I have rarely been inspired to make an image for myself – not that 'teacher' should do this anyway. *Taverna Lesbos* (see chapter 15) was an exception, but the rest of the party was otherwise deeply engaged. To stand in the same place, photographing the same thing, (or naked lady!) in my opinion, is artistically counter-productive. I regard my photography as a singular thing, like George Bernard Shaw said about eating, 'done strictly in private'.

There is really little more to say about this simple snapshot. It is an example of a thing hard to describe, but best defined perhaps by that tabu word, 'Intuition'. I just know when a good subject jumps in front of my lens, something more crudely called a 'gut feeling'.

Making a Bean Bag

1. Cut two pieces of soft leather ca 1mm thickness, as pictured.

18 cm (7½ inches)

18 cm (7½ inches)

2. Sew together on three sides, with the rawhide surface inside.
3. Turn inside-out, so that seam is inside and rawhide outside.
4. Sew a metal zip ca 12 cm (5 inch) long into the open side.
5. Add two small rings at top (zip) side for attaching a strap.
6. Fill with ca 460 g. (1 lb) of small beans mixed, white or pinto.

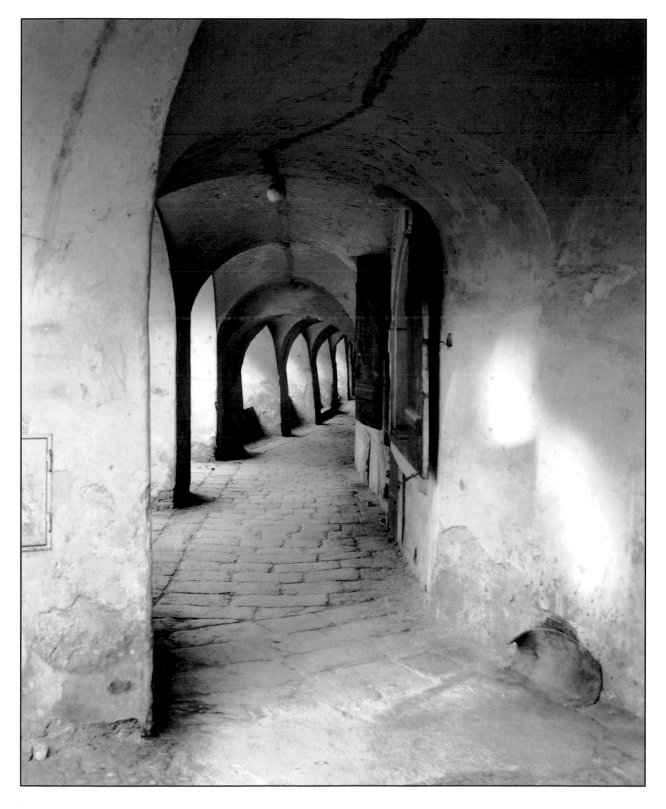

Old Prague 1992

VISUALISATION AND THE FASCINATION OF MIRRORS

Hôtel du Commerce

On walking into a musty, linoleum covered, floor-creaking room in a shabby Hôtel du Commerce, the first thing that caught my eye was the shower unit and wash basin reflected in a full length wardrobe mirror. I had a feeling that something unusual was going to emerge from that mirror: a different kind of interior photograph. But it was already late in the evening, and the bare 40 watt bulb hanging from the ceiling was certainly not giving off enough light to make a decent image. If the sun were to shine in the morning through those faded net curtains, I decided my first action – before breakfast – would be to capture this motif on film. The idea haunted me all night.

From the shadows beneath the curtains to the bright early-morning sunshine streaming through the window, the range of illumination was excessive. Dust glistening on the foreground chair was an unexpected bonus. A roll of 0.6 density neutral grey foil, draped outside the window, would have come in handy, the kind of trick I've seen TV and film teams use.

Knowing that it would be almost paper white in a print, I set the window on the edge of the image frame; there was no other choice. The room was so small there was only one spot – just inside the doorway – where the mirror first caught my eye and where all of the motif was visible in the Plaubel's viewfinder. Then the wardrobe door kept inching open, so I had to make sure that it did reflect the washbasin as originally seen. But other than doing something like that, I would never try to improve a still life; complete honesty and humility are just as important in one's photography as technical excellence. With the rise in digital imaging, such ethics today are probably old-hat!

At the time (the early Nineties) I was going through a phase of seeing subjects from a higher than normal viewpoint, perhaps subconsciously influenced by Edgar Degas' ballet school pictures – and others of the Impressionist school who featured mirrors in their paintings.

Viewed from above normal eye-level, this otherwise ordinary motif was further enhanced by the Plaubel's 80 mm Nikkor semi-wide angled lens, the equivalent of a 40 mm lens in 35 mm format. The camera already contained a roll of FP4 with several exposures made, albeit at normal shutter speeds, but this available light interior needed a one second exposure for the shadow values at the selected f-stop.

This was complicated by the fact that long exposures enter the realm of reciprocity law failure: a breakdown in the relationship of light intensity to exposure time. Mindful of this, but aware that my standard development process would cope with some overexposure, I counted 'one thousand and one, one thousand and two, one thousand and three'.

Reciprocity law failure (RLF; see p. 15) was first noticed in the 1880s by several researchers, notably the astronomer Scheiner. In German-speaking countries, RLF is named after Karl Schwarzschild (1873-1916), an astronomer-scientist who noted exposure time inconsistencies when making long time exposures of star fields on photographic plates. On investigating emulsion sensitivity at low light intensities he found that beyond $t =1$ second, exposures need to be factored several times the theoretical value. A similar effect occurs at exposures shorter than 1/10,000 second.

Mrs Todd – household engineer and tour manager – sees all these exotic journeys as welcome breaks from her daily routine, but for me they tend to become 'busman's holidays'; I spend most evenings developing films. Thus, during a decade of productive 'photo-safaris' in Europe and America, a Paterson Universal tank and chemicals in powder form, plus other tools needed for film development was (and still is) an important part of my travel pack. This mobile laboratory was especially useful in several long tours of the American Southwest, when the final 'booty' of exposed films numbered well over a hundred per trip.

Apart from the real fear of damage to a precious latent image through a faulty airport X-ray machine, it is often reassuring to see the results of a shoot while a scene or event is still fresh in the mind.

One might even want to do some, or all of it again. I achieved this once in the former Czechoslovakian Republic, after seeing the dissappointing results of the previous day's film. The second attempt was successful, and worth the 120 km back

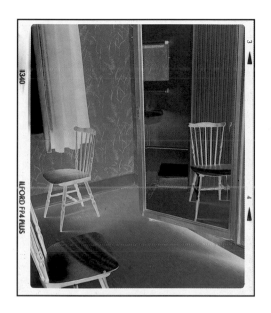

FR-93-3 67/08

Negative Data

Image: Hôtel du Commerce
Format: 6 x 7 cm
Camera: Plaubel Makina 67
Lens: 1:2.8/80mm Nikkor
Film: Ilford FP4 Plus
Developer: Ilford Perceptol

Print Data

Enlarger: D2 Aristo cold light
Lens: Rodenstock 105 mm APO
Fine print: Ilford MG IV-FB
Developer: Amaloco 6006 1:7
Toner: Kodak Selenium 1:20
Mounted size: 14 x 17 inches

to a churchyard in the High Tatras, and the motif I wanted so badly: my homage to composer Leoš Janáček.

Most manufacturers recommend developing a film as soon as possible to avoid image regression, which can occur if a film is left for too long before it is developed. On the other hand, I know from experience that a latent image can survive for ages in silver-halide.

A few years ago a colleague gave me a roll film that he had found in an Agfa box camera; with faded red backing paper, it was clearly very old, possibly a 620 Adox or Perutz from the early 1950s. I developed it in ID 11 diluted 1:1, starting at twenty minutes in case the film was in poor shape, then, just to be sure, adding five minutes in mid-process. Undiluted developer would have saved time! Whilst there was considerable loss of silver at each end of the roll, a couple of the images produced quite respectable prints of a family group. On returning the film to its owner, he identified the boy in one of the pictures as himself – 27 years younger!

Hôtel du Commerce was left a mere twenty-four hours, before development in yet another hotel bathroom. After a day searching for new motifs, what better way to relax – especially with a glass of wine while the films are washing! Despite the problems that could occur by developing films in relatively primitive conditions, it is a risk worth taking. First, I check the bathroom or toilet lights to ensure they cannot suddenly illuminate the room and ruin a film; the best solution is to unscrew the lamp. Windows can be a problem too. Hotel receptionists can give slightly strange looks when asked if their bathrooms have windows! I used to have a blackout cloth, until it got left behind, still taped to a bathroom window. The American motel room cleaners must have wondered what had gone on in there.

Water quality is often another unknown, chemically and mechanically, so it might pay to run the water through a normal coffee filter paper to remove any grit before mixing the developer. Whether the water is hard or soft is difficult to check, but it is probably not good at either extreme. To hold the temperature at around 20°C during development I stand the tank in a washbasin filled with water about two degrees warmer. The containers of ready-mixed stop and fixer are tempered in the same bowl (see p. 15). This is my normal procedure at home, so why not do it 'on the road'.

The digital thermometer seen here is one of five temperature-measuring devices (including a Jobo Autolab) in my darkroom. One is a mercury thermometer calibrated to 0.1° accuracy, while the electronic model differs from the latter by 0.4°C. Between the lowest and highest of all five is a range of 1.6 degrees. This reminds me of a saying attributed to Confucius: Man with one clock knows time; with two clocks not. My point is that, within reason, it doesn't matter, as long as you always use the same yardstick. Absolute values are irrelevant.

I check the developer temperature again before the process ends to see if the time should be lengthened or cut short quickly. Then, after pouring off the developer, I give the tank a quick rinse to ensure a minimum of carry-over into the

"On the road again ..."

stop and/or fixer baths. Once, at this point in the procedure, I absent-mindedly opened the tank lid but then quickly realised what my hands were doing! Luckily, as the developer had been rinsed away, there was no adverse effect. I would not recommend this trick to others; it might produce a rather nice image reversal, though this is more likely to happen if the tank is still full of developer and you are standing under a strong light.

Film washing (five minutes steady flow, or ten complete changes of water) is followed by a couple of minutes in distilled, or still table-water, with several drops of wetting agent added (Ilfotol or Kodak Photo-Flo, ca 1%) to avoid drying marks. The bottom half of a discarded five litre container makes an ideal portable mini-tank for the distilled water (see above). Taking the film out of a spiral is perhaps the most critical step; it also has the potential of being a disastrous operation. However, the universally popular plastic spiral allows one to remove the film without touching it - simply hold the spiral horizontally while separating the two halves, and

LIGHT, TIME AND EMULSIONS – RECIPROCITY LAW

The exposure of photo-sensitive materials is found by the equation: $E = 1 \times t$. Any change in either of these two factors i or t will result in a different exposure E while *reciprocal* changes to i *and* t do not.

As always, nothing is perfect. The well established law of reciprocity is good only over 'normal' photographic usage, that is between 1 and 1/10000 second.

In their book *Photographic Sensitometry*, Hollis N. Todd (no relation) and Richard D. Zakia define the law as this: '*the image formed by a radiation sensitive process is dependent only upon E, not on the i and t components of the exposure. The failure of the law means that the image is indeed dependent upon the two factors which make up the exposure.*' In other words, the reciprocal relationship between i and t begins to fail when either of these factors reaches extremes, whereupon the emulsion is not exposed in accordance with its normal sensitivity range.

A simple water jacket for temperature control.

drop the film(s) into the distilled water. I never use that old Pro's trick – running the inside of one's fingers down the film. It's a sure way of getting 'telegraph wires' through every negative caused by a single grain of grit. Gravity does a better job while I hold the film aloft at 45˚, letting any surplus liquid flow off the lower edge. Finding a place to hang the films overnight in the average motel or Pension is often a puzzle, though usually there are a few clothes hangers in a wardrobe with doors that one can close to keep dust at bay. Some string, a couple of pegs and a dash of ingenuity come in handy at times.

Hôtel du Commerce is an interesting negative to print on RC or FB papers, but as expected the window highlight was almost beyond help. A substantial burn with Ilford's grade 00 filter helped to restore some tone in that over-exposed window – raising it above paper white; otherwise, it prints easily on Ilford Multigrade IV FB at grade 2½. This ensures that the basin does look like white porcelain; it also provides good tonal separation between the wall and the dark curtain.

As in most black and white printing, the paper grade, its exposure and development defines the range of tones. My preference, generally speaking, is for retaining fine structure in the lighter tones that can be easily resolved, rather than showing the very last ounce of shadow detail. In any case, one can only really detect the differences in black tones beyond about D = 1.8 with a densitometer. It is not enough to have stunning blacks and brilliant whites; a full range of grey tones between these two extremes is far more important, a quality that is guaranteed by a well-exposed and properly developed negative. Incidentally, the numbering and manufacturer's brand name on the film's edge and the fogged leader on a 35 mm roll are other indicators of proper development – if it's a thin black, then something is not right.

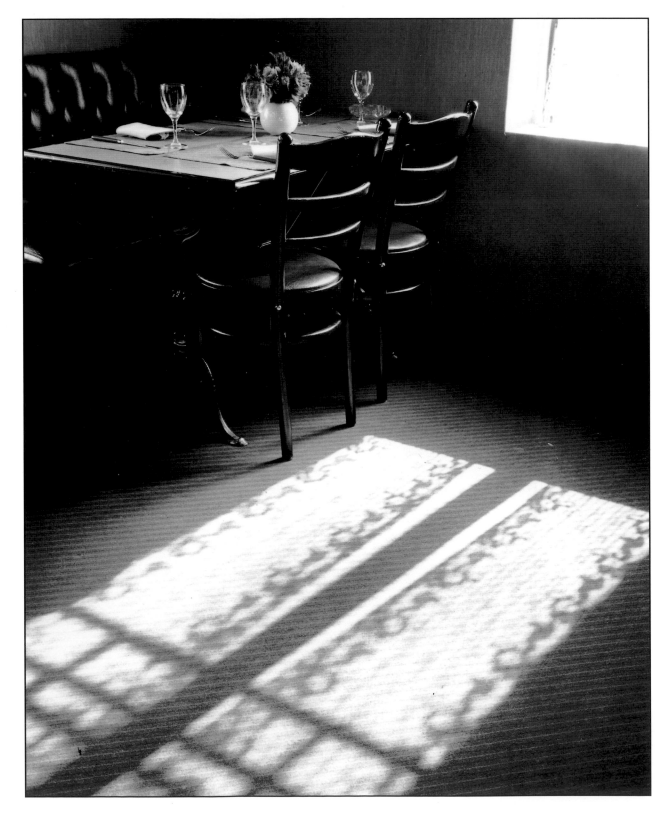

Shadows and reflections always fascinate me.

A shady corner Jura, France

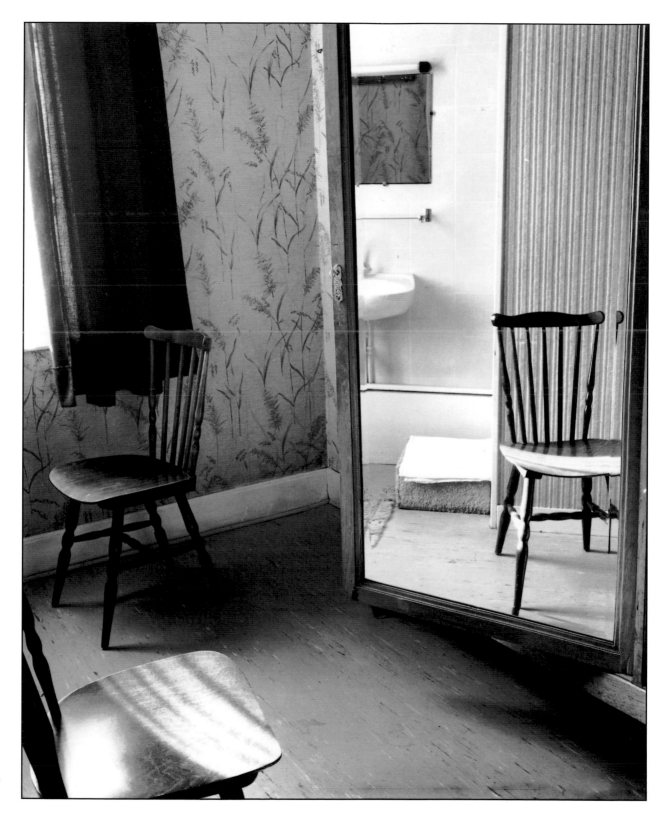

Hôtel du Commerce

SHADOW CATCHING
Bedroom Fantasy

As a long-time resident of Gloucestershire, I was familiar with the name John Cabot, honoured for seafaring deeds by a tall tower overlooking the Avon Gorge at Bristol, his port of departure from which he embarked upon a remarkable journey of discovery. On the other side of the Atlantic, there is another monument to Cabot – in Newfoundland, where he first glimpsed the North American mainland in 1497.

It was thus an attractive idea (my wife's, naturally) to look for images of a different kind in this former British colony, a land that reminded me of some northern parts of Scotland or Greenland, a place I've worked and travelled in, winter and summer. Crossing to Labrador in mid-June through a scattering of ice floes, it occurred to me that being on a similar latitude, the sight of majestic icebergs floating southwards between Birkenhead and the Isle of Man would probably be an annual occurrence without the Gulf Stream's beneficial warmth.

On the west coast of Newfoundland, somewhere along a twenty mile long spit of land called Port au Port, we found a newly opened B & B in the remote community of Winterhouse. What a fitting name; one could just picture this place with a bleak January gale blowing. When the lady showed us to our room, I immediately dropped the bags in the doorway and began settting up the tripod and Hasselblad camera. Both my wife and our hostess wondered what on earth was happening. Neither had seen what had grabbed my attention so suddenly: a fabulous shadow on the strange, carpet-covered wall lit by the late afternoon sun. Although the contrast range was a bit high, with some hot spots on the sunlit bedcover, it was not too difficult to handle at ISO 80 – my normal rating at the time for Kodak TMX developed in Perceptol.

After all that excitement I sought a breath of fresh air in the nearby churchyard on a grassy cliff top, with mainland Canada clearly visible across the Gulf of St.Lawrence – and found a different sort of motif: fenced-in graves, the kind of scene that exercises the graphic eye and exposure techniques; an image reminiscent of Paul Strand's famous white paling fence. There were similar sights all over the island, rocky landscapes with timbered buildings typical of coastal

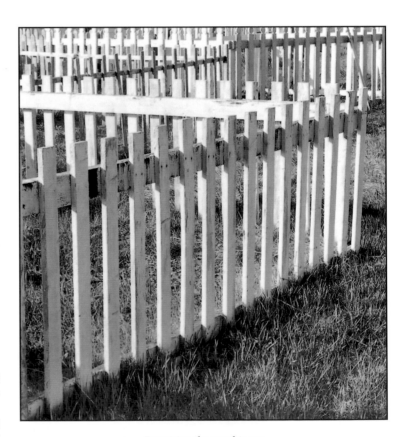

Exercising the graphic eye.

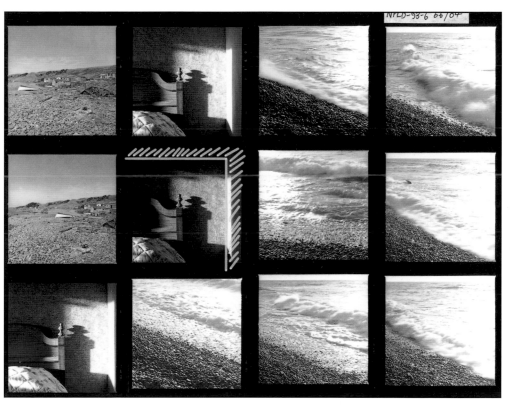

Negative Data
Image: Bedroom Fantasy
Format: 6 x 6 cm
Camera: Hasselblad 500 CM
Lens: 1:3.5/60mm Zeiss Distagon
Film: Kodak TMX
Developer: Ilford Perceptol

Print Data
Enlarger: D2 Aristo cold light
Lens: Rodenstock 80 mm APO
Fine print: Ilford MG IV-FB
Developer: Amaloco 6006 1:7
Toner: Kodak Selenium 1:20
Mounted size: 13 x 15 inches

settlements so often depicted by the American school of East Coast photographers.

Naturally I was anxious to see these negatives – the first of our Newfoundland tour – as soon as possible, but at such latitudes it is still quite light in June, even at midnight. So the search was on for a place dark enough to load the developing tank. The only suitable spot was not *in* the house, but *beneath* it. As in most northern latitudes, the building was on stilts to isolate it from the ground in winter. I slid through a trapdoor in the floor and, in what must be the weirdest of all darkrooms, began loading films. Moments later, a sudden shaft of daylight illuminated this horrible hole full of creepy crawly things; children wanting to watch the proceedings had crawled through a side door in the panelled-in space under the house! My cry of panic scared the kids off as I quickly covered the tank with my hands. Luckily the films were not affected. Among the satisfying results was this image, one that simply jumped off the wall at me.

This unusual motif highlights a theme that runs through so many of my images, whether in black and white or colour – shadow catching. The fantasy world of shadows has always fascinated me, the ephemeral shapes and dancing forms – like the images we conjured as kids with our fingers in the flickering light of a magic lantern. Fleeting shadows seem to epitomise the transient nature of everything, including ourselves. The picturesque notion of photographers as 'shadow catchers' is by no means new; it stems from the American Indians. They gave this evocative name over a century ago to the strangers who stuck their heads under a black cloth that stood on three legs, the persons who '*with the powerful Sun's assistance, were able to capture and transfix shadows.*' [1]

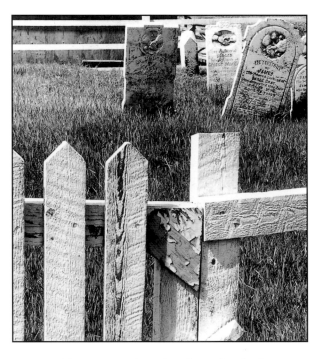

There were similar sights all over the island

[1] *Dwellers at the Source; Southwestern Indian Photographs of A. C. Vroman 1885-1904; William Webb and Robert A. Weinstein, University of New Mexico Press, Albuquerque, 1987.*

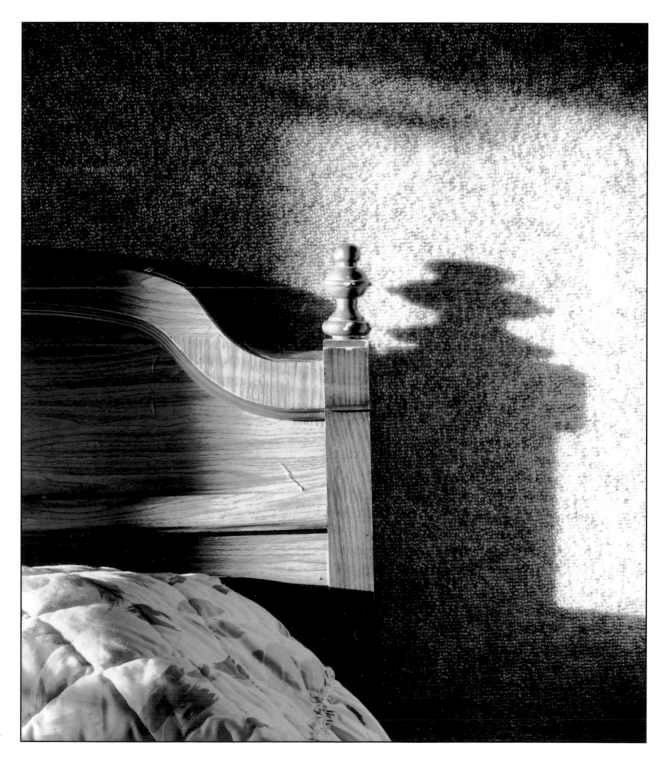

Bedroom fantasy

A GOOD MOTIF HELPS

Works Entrance, Ornans, Jura

Like so many others in my collection, this image was pure serendipity. The OED defines this fittingly as: 'The facility of making happy and unexpected discoveries by accident'. I stumbled on *Works Entrance, Ornans* during a brief tour of the French Jura, an attractive region of limestone mountains, deep caves and bubbling rivers bordering Switzerland. There are many beautiful rivers in the Jura, but one in particular – the Loue – emerges from a Stygian world of sinuous caverns via a hole in the cliffs that geologists call a resurgence. It cascades into a landscape photographers and painters dream about, and fishermen delight in.

Downstream, straddling the Loue, is the medieval town Ornans, where the river is lined with some quite photogenic bridges and fine old warehouses. Among its notable citizens was Gustave Courbet, one of France's most influential 19th century realistic painters. During an after-dinner stroll along a rather uninteresting street, a large disused building attracted me like a pin to a magnet. You develop a sixth-sense for these things. In the empty forecourt there was an evocative air about the place, something one can never describe – a promise of exciting new images. On pushing the main door open, this old stairway held me riveted to the spot. Surprisingly, I didn't venture up those stairs to see where they might lead. Maybe this is why they fade into deep shadow, as if to keep some dark secret. I noted that the morning sun would probably light the building's façade, and went to bed hoping for fair weather.

Carefully retracing my steps the next day, I soon found the building again and gingerly entered a silent courtyard; the place was still deserted. It needed very little effort to compose an ideal arrangement of door and stairs, now illuminated by diffuse morning sunlight. I set the camera on a Linhof Profi-Port tripod (solid, yet fits into a briefcase) using the central column extension tube to get more height and avoid converging lines. There was just enough space to squeeze my head between the wall and the camera, and to focus and ensure that the doorway and stairs were all visible in the image frame. The Plaubel's built-in light meter gave an accurate reading for the shadows under the stairs, while the off-white plaster behind the door fell comfortably within a 5 f-stop range.

To get a good depth of field, the available light called for f-16 at a slow shutter speed, which in turn meant a long cable release; too short a cable might jerk the camera. I made three exposures on Ilford FP4 (an old favourite of mine) bracketing each one just a touch – perhaps as little as 1/6 f-stop on the Plaubel's continuously variable aperture control.

As in the previous example, this film was developed the following evening in the bathroom of a hotel. At the time, I had gone away from the Ilford recommended agitation method in favour of a slow 'rhumba roll' as a workshop student called it. After comparing four different methods: Agfa, Ilford, Kodak and à la Todd, we concluded there was little to choose between the various agitation methods. On the other hand, the Kodak method reminded me more of a cocktail shaking job than film development.

The first time I developed a roll of Kodak Technical Pan in Technidol LC I nearly collapsed on the darkroom floor laughing at the impossible sequence of violent 'paint pot' shakings one was supposed to perform within ten seconds! Rapid or violent agitation like this will lead to over development and an increase in contrast and grain – maybe that is what you want.

There are probably as many ways to agitate a film in development as there are to peel an orange. If ten photographers were each given an identically exposed film to develop, the result, I am sure, would be ten completely different sets of density figures. However, agreement with data sheets is not the point; being consistent in what *you* do is a more important thing to achieve.

Agitation à la Todd is based on a slow twisting, turning motion as pictured in Norman Sanders' *Photographic Tone Control*[2]. This easy-to-read book is a refreshing change from some of the more arcane handbooks on the subject. I was particularly attracted to his agitation method as a means of maintaining a not too turbulent flow over the emulsion surface. Sanders also describes some simple step-by-step procedures, based on established densitometric principles, for calibrating a camera, film exposure and development especially for users of 35 mm equipment.

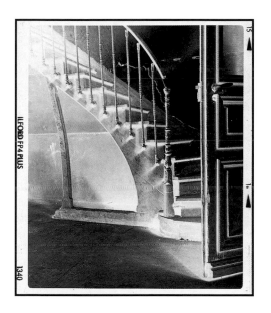

Negative Data
Image: Works Entrance, Ornans
Format: 6 x 7 cm
Camera: Plaubel Makina 67
Lens: 1:2.8/80mm Nikkor
Film: Ilford FP4 Plus
Developer: Ilford Perceptol

Print Data
Enlarger: D2 Aristo cold light
Lens: Rodenstock 105 mm APO
Fine print: Ilford MG IV-FB
Developer: Agfa Neutol WA 1:7
Toner: Kodak Selenium 1:20
Mounted size: 14 x 17 inches

Later I returned to the Agfa prescribed method of continuous inversions for the first minute, followed by two inversions (my twist 'n' turn kind) of three seconds duration at each half minute interval. Now I use a combination of Agfa and Ilford procedures: ten seconds agitation in the first minute, followed by two inversions each half minute. It seems to give more even development *across* the film.

This was after I noticed that some films tended to develop slightly less along the upper edge, to a depth of a few millimetres, maybe caused by leaving the tank standing at rest for one minute between inversions. A gravitational effect, perhaps, but in a well-filled tank? When developing only one film in a small hand tank, I use the recommended volume (in this case 500 ml) but with two 120 rolls on the same reel, I fill it with 600 ml to ensure proper development, even though I *know* that 500 ml will do the job.

Other workers seem to devote so much time to testing different developers and techniques that they make me anxious, giving me the feeling that perhaps I am missing something. On the other hand, there is much to be gained, in my opinion, from staying with an old favourite and perhaps fine-tuning one's method to the 'nth degree'. The problem is that, at my age, time disappears in a logarithmic manner, each day becoming a smaller percentage of the total. I would rather spend these precious moments looking for and capturing new images or learning to print better.

Developed in Perceptol 1:1, *Works Entrance, Ornans* turned out to be a fine-grained negative with an ideal range of densities from 0.10 above f+fb (defined on p. 32) to a maximum of D = 1.2. It enlarges easily up to 24 x 30 inches on fibre base paper and was used in a product display by Ilford Imaging at the 1994 Photokina.

[2] *Photographic Tone Control Norman Sanders, Morgan and Morgan, New York 1977.*

A FEW WORDS ABOUT DEVELOPERS

Brief history
Gallic acid, used first by Fox Talbot in 1840 (see below).
Hydroquinone; goes back to 1880 and is the basis of many modern developers, either on its own or in combination with other developing agents.
Phenidone; discovered in 1890 and used in the textile industry as a reducing agent; only discovered to be an effective developing agent in 1940 and produced a decade later. Its special 'super-additivity' feature is also exhibited by a number of other developing agent combinations including Metol and hydroquinone.
Pyrogallic acid or *Pyrogallol* was first used in 1850 and is currently enjoying a revival among fine art workers as *PMK* Pyro.
Metol or *Elon*; first produced in 1891 and marketed under numerous names; known as Metol in Germany and used in combination with hydroquinone in Kodak D76 and Ilford's ID11. These are sometimes known as "MQ" developers.

Some applications
In addition to the old standards like ID11 or D76, some 'fine art' photographers prefer highly concentrated developers such as Kodak HC110 and Ilford Ilfotec HC prepared in very dilute foms, i.e. 1:31 parts water. At this dilution, one litre of Ilfotec HC contains almost as much hydroquinone as stock ID11.
Developers like Agfa Rodinal or Tetenal's 'one shot' ampule varieties of Neofin, prepared as working solutions, are *very* dilute and provide compensating development and impoved sharpness.
Proper agitation is essential with most dilute developers because they quickly become exhausted in the dense silver areas (e.g. highlights), while continuing to develop in the shadow areas. The results are often negatives with a much compressed density range. Films exposed with extreme subject luminance ranges can be developed by using special methods, e.g. two-stage developers, and water bath techniques.

Agitation methods, à *la Todd.*

Duration of one complete cycle, approximately three seconds.

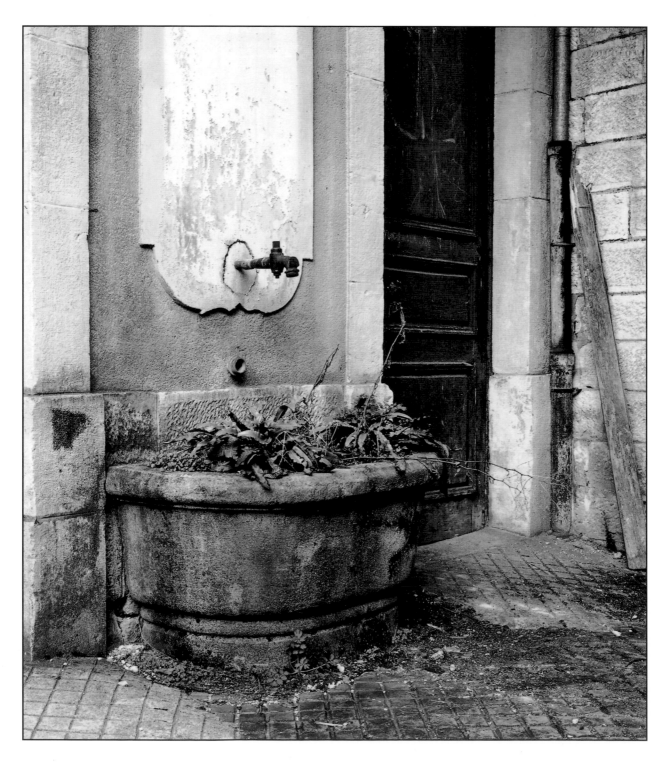

Works courtyard

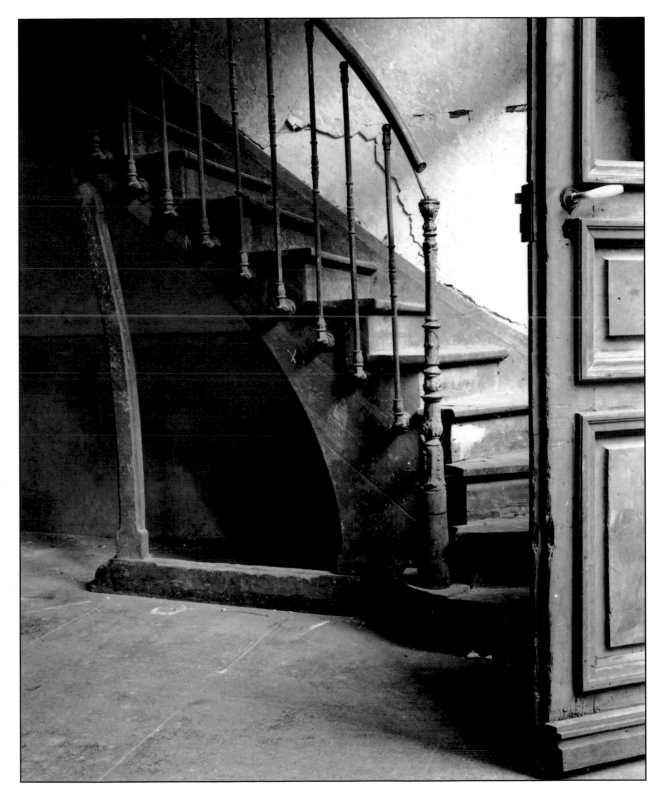

Works Entrance,
Ornans.

SLOW TRAINS AND FAST FILMS

The Station-master's Office

I was driving idly along empty country roads in south-central Portugal, with a warm afternoon sun adding to the Christmas day post-luncheon glow, when a sign, signalling a railway station near Beja, caught my attention. This was quite a surprise; there are few local lines still running these days, anywhere. It was all the more pleasant, especially on this public holiday, to find the small station filled with people waiting for arriving friends, or to catch the next train. Moments later, not one, but two long, diesel-powered trains came lumbering into the station from both directions almost at the same time, stopping side by side. Windows were immediately flung open in opposing compartments and people quickly joined in loud and animated conversation, helped, I am sure, by the festive spirit.

Amid the general platform bustle, I noticed that the station-master's office door was ajar, revealing yet another challenging interior crying out to be put on film. Naturally I asked the gentleman's permission to photograph in his office. 'No problem' he consented, reaching for a bottle of port and two glasses, 'but first, we must drink to Christmas'. Yet another surprise, and a change from signs warning 'Keep out' or '*Eintritt verboten*'. After that, I *had* to make a good job. I opted for a hand-held shot with a Nikon F3 High Eyepoint version and a 28 mm lens, instead of my usual medium-format camera and tripod set-up. The Nikon was ready loaded with the then relatively new Ilford DELTA 400 fine grain film, on my way to get some official shots of the German pavilion at 'Expo 1992' in Seville.

Automatic cameras are anathema for me, so I switched to M for manual and set the ASA dial to nominal 400 ISO. Following that often quoted golden rule: 'expose for the shadows and develop for the highlights', I placed the meter readings (*always* middle grey as default) where they *should* be, not as the light meter indicated. This is a basic tenet of Ansel Adams' famous Zone System, discussed briefly in chapter six. The timetables scattered around the station-master's desk were lit by a neon strip-light on the ceiling, with some daylight from the window, giving an exposure value that I knew would be wrong. They needed to be two and a half f-stops *more* than the Nikon's meter showed.

Similarly, the black telephones and dark areas behind the desk gave a reading

that would have over-exposed those motif parts by two stops. The exposure used was thus the middle of the two measured values. It was a classic range of subject luminance, practically the same as my standard light meter test described in the next chapter.

Again, with no time to use a tripod, a bean bag would have been useful. The next best thing as a support was the doorway, the same viewpoint as my first glimpse of the office. I stuck my cloth cap under the Nikon, holding it firmly against the doorpost during the quarter-second exposure. Wishing not to overstay my welcome, one exposure had to suffice. Later that Christmas night, it was a relief to see a really pin-sharp fine-grained negative – a result of the developer (Perceptol diluted 1:1) and my development methods described earlier. For a 400 ISO 35 mm format film, the resolution is quite remarkable; even the station-master's handwriting is legible on the timetables.

As the contact print on p. 29 shows, I did not get the image verticals quite upright. For an exhibition print, a little 'Scheimpflug' was used to correct this. Known among photographers for his theory of perspective control, Theodor Scheimpflug (1865-1911) was a Captain in the Military Geographic Institute in Vienna where he specialised in photogrammetry. He developed a method for perspective correction of oblique images made in surveys from airships for photographic maps. Scheimpflug also invented equipment for image rectification.

In studio or architectural photography, Scheimpflug's system of perspective control and the avoidance of 'falling lines' is achieved through movements – by swinging and/or tilting a lens or film plane of a large-format camera. This technique can also be used to correct falling lines in an image projected by an enlarger. It works best when the negative stage, as well as the easel, can be swung in either direction. The whole image plane remains sharp in this method (see sketch).

However, as the negative stage on a D2 Omega enlarger is fixed, such perspective problems can only be straightened out by tilting the easel at either end (or side). A small wedge under the bottom edge of the easel was sufficient to correct the converging lines in this image. It was then only necessary to stop down

Negative Data

Image: Station-master's Office
Format: 24 x 36 cm
Camera: Nikon F3 HP
Lens: 1:2.8/28mm Nikon A1
Film: Ilford Delta 400
Developer: Ilford ID 11

Print Data

Enlarger: D2 Aristo cold light
Lens: Rodenstock 80 mm APO
Fine print: Ilford MG IV-FB
Developer: Ilford Multigrade 1:9
Toner: Kodak Selenium 1:20
Mounted size: 8 x 11½ inches

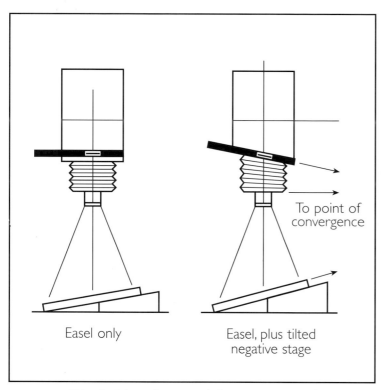

Using the Scheimpflug Principle for perspective control

To point of convergence

Easel only

Easel, plus tilted negative stage

more than usual (f11/16) to ensure overall sharpness based on focusing at a point somewhere near the middle of a ca 15° slope.

Being a long-time user of medium-formats, I still find the 35 mm format too restrictive, its curious two to three ratio awkward. There always seems to be something just outside the image frame. From this point of view, a square-format camera makes best use of the lens' circle of coverage – the classic square (peg) fitting a round hole. The next best fit is 6 x 7 cm, followed closely by the 5 x 4 inch format. When we consider resolution versus size, a 35 mm negative has an area of 864 sq.mm, while a 6 x 6 negative at 3025 sq.mm has a three and a half times greater area of emulsion for any given part of a subject, reckoned in 'pixels' nowadays. By these standards, a 5 x 4 inch negative has virtually acres of emulsion available; bigger is certainly better, but only when focused properly! From a printer's point of view 6 x 7 cm is the ideal format. A seven times enlargement of a 6 x 7 negative almost exactly fits a 20 x 16 inch sheet of paper, which is about right for most exhibition purposes.

ABOUT FILMS

There is a broad palette of films for pictorial or still life subjects, for example:

• Agfa APX 25
• Ilford Pan F
• Kodak Technical Pan
• Polaroid 55P/N

These are slow, or very slow speed films, with nominal sensitivities ranging from 25 to 50 ISO, depending on the type of developer and the dilution used. Kodak's extra-fine grain Technical Pan is as good as a micrographic film. When exposed at ISO 25 and developed in Kodak Technidol LC, Technical Pan (TP) is capable of extremely high resolution of around 300 line pairs per millimetre (lp/mm). Higher up the sensitivity scale, several medium speed films offer fine grain and a high degree of sharpness with resolutions of 80 to 100 lp/mm.

• Agfa APX 100
• Fortepan 100
• Ilford FP4 Plus
• Ilford DELTA 100
• Kodak Plus-X and T-Max (TMX)

High sensitivity films (ISO 400) are used in all forms of photography, particularly sporting events. Kodak Tri-X, a standard workhorse of high- speed films, or HP5 and now DELTA 400 from Ilford or Fuji 400 are all commonly used in the profession and by amateurs. Kodak TMY at ISO 400 has exceptionally fine grain and resolution owing to its "T" grain crystal structure. It can easily be pushed to EI 1000 with very little loss of definition; graininess can be held to acceptable levels by using a fine grain developer. Like its ISO 100 sister, DELTA 400 features 'Core Shell' technology, with truly remarkable definition ideal for all branches of photography.

Kodak 3200 (only in 35 mm) and DELTA 3200 are favoured in photo-journalism because they can push these films easily to 6400 - even up to EI 25,000. One could almost photograph in a darkened room!

Two chromogenic films complete the picture: Ilford XP2 Super and Kodak's CN 400. Nominally ISO 400 films, with tremendous latitude from 50 to 800 ISO, they perform best at ISO 200 or 160. Both XP2 Super and CN400 have silverless images after processing leading to doubts about the archival stability of dyes. Properly developed and fixed silver images exhibit stability measurable in tens of decades, maybe even a century, depending however on the base material.

STANDARD LENS FOCAL LENGTHS VERSUS FORMATS

Format	Focal length	Diagonal	Angle of view*
35mm	50mm	43mm	40 deg.
6 x 6 cm	80mm	80mm	40 deg.
6 7 cm	90 mm	88 mm	46 deg.
4 x 5 inches	150 mm	150 mm	43 deg.

*horizontal

Comparison of film formats

The more the better. A greater area of emulsion means higher resolution.

4 x 5 inch

35 mm

6 x 7 cm

6 x 6 cm

MORE ABOUT FILMS

Graininess is the subjective appearance of silver density.

Granularity is an objective measurement of the emulsion structure. The two terms are not interchangeable, though they are related; greater granularity means a greater appearance of grain. The visual appearance of grain is related to numerous factors: the film, developer and development method, and the resulting density. Graininess in a print can be enhanced (or reduced) by the enlargment size, the paper grade and chemistry used. Viewing distance is also a determining factor.

Contrast is a function of a film's design (over which we have no control) and the type of developer, temperature, time and agitation, all of which we can adjust.

The term "**fb+f**" describes what we see on any film in the parts without an image, between each frame or at either ends of the film. Its density consists of two parts: the film base and a chemically generated fog. It produces total black in a print. While film base (**fb**) is a design constant, fog (**f**) is variable and depends on several factors: the developer used and its condition, the developing temperature and time, and the agitation method. With some films, e.g., ISO 3200, excessive fog can result from exposure to LED's, fluorescence on timers, or from afterglow in strip-lights and light tables while loading a high speed film into the developing tank.

ADAMS'S ZONES
(the non-erogenous kind)

The definition of motif zones is as follows:
Low reflectance values: zone I to III
Middle values: zone IV to VI
High values: zone VII to X

Zone V is normally referred to as the middle or reference grey value, based on a standard subject reflectance of 18%. This lies in the *geometric* middle of a typical subject reflectance range from ca. 4 % to over 90 %, i.e. from black to white. Individual motif zones can be described as follows:

Zone	
0	No density; film base+developed fog; total black in print
I	Lowest recordable value; threshhold of negative density
II	First near black density; structure barely visible in print
III	Typical of dark objects, with structure visible
IV	Shadow areas in portraits, landscapes and still-life subjects
V	Middle value; old wood, green grass, weathered limestone
VI	Blue sky midday, concrete, Eurasian skin (not suntanned)
VII	Average cloud whites, light subjects, fair skinned persons
VIII	Snow-white, with faint structure visible in print
IX	Bright white snow; max density printing as paper white
X	Textureless white, beyond printing.

With most cameras, the standard lens focal length is nominally based on the diagonal of the image frame, while it is the horizontal width of the image that defines the angle of view (see box on p. 31). On a Hasselblad medium-format camera, for instance, where the image frame is 55 x 55 mm, the diagonal and standard focal length is 80 mm. In the so-called miniature film format (35 mm), the 24 x 36 image diagonal is 43 mm whereas the standard focal length is 50 mm.

In the general discussion over films and formats we tend to forget however that *all* lenses project a circular image. George Eastman's famous ten dollar: 'You push the button, we do the rest' camera of 1888 produced circular pictures. Perhaps it is time to revive this attractive format.

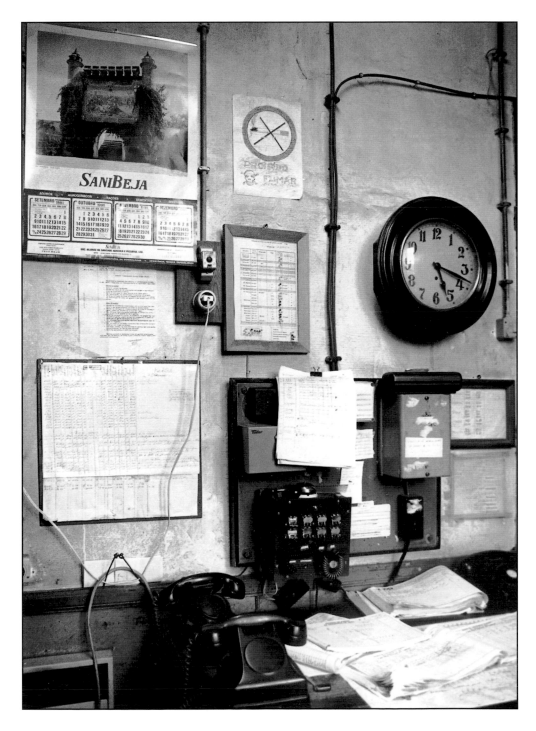

The Station-master's Office

SEEING THE LIGHT (AND DARK)

Bavarian Lake in Winter

Soon after my return from a two-year working residence in Alabama in the early Eighties, I took part in a three-day seminar held by the Munich Volkshochschule, or adult further education school. The subject was the Ansel Adams' Zone System and the lecturer was Peter Fischer-Piel, Germany's first and youngest high priest in this much discussed topic. The second and most controversial of Peter's two books was awarded a Kodak Book Prize in 1990. I was curious to see how much acceptance Adams' exposure and contrast control system had gained on this side of the Atlantic. Out of fifteen participants, half of whom claimed to be studio professional photographers, I was the only one with previous practical experience of the Zone System. Fischer-Piel was surprised, too, at this lack of knowledge. Some of the people attending were clearly sceptical of its value.

The Zone System's roots go back to the 1890s when two scientists, Ferdinand Hurter and Vero Charles Driffield began studying the properties of light-sensitive materials. They established a basic set of laws to describe the effects of energy (as light) on photographic emulsions, and they described density as being the amount of silver reduced by chemical action. 'H & D', as they later became known, found that photographic emulsions behave 'in a clearly definable way that no chemical or tricks could change'. The relationship of one tone or density to another stayed the same – a dark tone always remained darker than a lighter tone. They showed this by means of a graph, plotting the sensitivity of a film over a range of exposures against the density of the developed silver. This is called the Characteristic Curve, and is published as standard data by all film manufacturers. It is still known as 'the H & D curve' by some older workers. H & D's original findings gave photographers a tool for creative control over effects that previously were only accidental happenings. Curiously, the two axes of this curve are abbreviated in German to H & D (*Helligkeit und Dichte*).

Few photographers realised the importance of Hurter and Driffield's work, which remained relatively obscure in the more esoteric corners of photography, until 1940 when John L. Davenport proposed a reliable method of exposure and contrast control. Davenport's system was based on using a Weston 650 light meter to measure the subject reflectance.

A few years later, Ansel Adams (assisted by his co-worker Fred Archer) further codified the system, designating Roman numerals from 0 to X to cover the range of subject luminance. Adams called them 'zones', 0 being total black on photographic paper and base white as X, thereby dividing the range of grey tones into eleven equal density steps. But why a symbol 0? The Romans didn't even know of it; the earliest occurrence of the Arabic 0 in Europe is found in 12th-century manuscripts. However, some workers engaged in the further advancement of the Zone System have reduced it to ten steps, beginning with zone I for the film base, plus the inherent, developed fog. Both Davenport and Adams stressed the importance of cultivating the ability to *previsualise* a subject in terms of these grey tones, and their realisation as a black and white print. (Note the use of *zones* to delineate reflected light values in a motif, and *tones* when describing the grey values in a print).

Learning to see any motif as a range of grey tones is helped by viewing the subject through a Kodak Wratten # 90 filter. This has the effect of reducing a scene to monochrome tones, but the eyes will revert to seeing the colours again in their normal relationship if too much time is spent looking through this filter. Next time you are doubtful as to whether a motif is worth the film, and the effort, try viewing it with one eye closed. Without the three dimensional effect of normal vision you will soon see if it looks uninteresting as a flat picture. Recognising the potential of a subject, assessing the critical zones of light and shade, and visualising them as they will appear in a print, are perhaps the most important creative faculties a photographer can develop.

Seen near Oberammergau of Passion Play fame, *Bavarian Lake in Winter* is a prime example of applied Zone System techniques. On nearing the end of a chilly March photo-session around the still ice-covered Lake Bayersoiern, my attention was attracted by this tranquil scene. While setting up the camera – a lightweight wooden 5 x 4 inch Ikeda Field with a Rodenstock 150mm* Sironar N lens – it

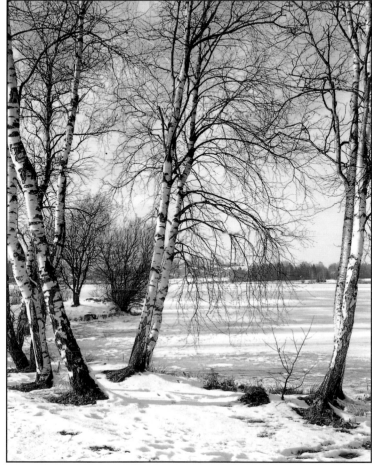

Negative Data

Image: Bavarian Lake in Winter

Format: 5 x 4 inch

Camera: Ikeda wood view

Lens: 1:5.6/150mm Rodenstock
Sirona N

Film: Ilford FP4

Developer: Ilford ID 11

Print Data

Enlarger: D2 Aristo cold light

Lens: Rodenstock 80 mm APO

Fine print: Ilford MG IV-FB

Developer: Ilford Multigrade 1:9

Toner: Kodak Selenium 1:20

Mounted size: 14 x 17½ inches

MEASURING LIGHT

(by a separate meter – the key to better images)

There are two methods:

Incident light measurement. Non-interpretive, it is rather like our own vision; we see the quantity of ambient illumination and regulate (via our irises) the amount of light to the retina – or in this case, film.

Reflected light measurements on the other hand, allows interpretive, creative manipulation of subject luminances. Zone system users generally favour this method over incident light measurement (equally creative) which is used more in commercial photography and film studios.

The reading is always zone V (middle grey)

occurred to me that it is not always necessary to depict the whole tree. Why not compose a picture of a group of trees showing only part of them? There are too many pictures of single trees, or landscapes centred on trees, but rarely anything novel or exciting. Not that this image breaks any new ground either; it simply radiates a quiet harmony, while depicting a rather dull overcast sky – and chilling cold (see picture on p. 41).

With a warm spell threatening, the ice was certain to melt – and a year was too long to wait for a second attempt. There was also only one sheet of film left, so this was a negative that simply *had* to be properly exposed. I based the reflected light measurements on my then current EI of ISO 50 for Ilford FP4, using an analogue Pentax V Spotmeter adapted with a scale of zones (see photo), but cannot recall the exposure settings; I feel that they are never that important, retrospectively. In any case, when I'm making a landscape or a still life in daylight, my meter nearly always reckons 1/30 second at f-11, confirming Ted Orland's emphatic statement in Photographic Truth[3]: '1/60 at f-8 is the correct exposure for *all* photographs'. But, don't take this too seriously; that meter of mine might be wrong.

I used a Jobo ATL-2 Plus Autolab to develop *Bavarian Lake* along with three other FP4 sheets in Ilford ID11, diluted 1:1. The resulting densities matched the measured 5 f-stop range (zones III to VII, as ringed in the illustration) where the lower shadow value was 0.32 and max D = 1.00 above f+fb. In contrast to manual processing, the Jobo's characteristic oscillating rotation has the effect of reducing developing times by some 10 to 15%. Some of this machine's film processing programs include a five-minute prewash, which lengthens the total process time by up to 15%, back to square 0, as it were.

In my opinion, prewashing films is of little value. Indeed, while removing the anti-halation coating (more substantial on some films than others) it may also wash out ingredients useful to the development process, and thus be detrimental to proper development. If one is working in a desert for instance, where dust could be a serious problem, a prewash *might* help remove an errant speck of dust from the emulsion surface before pouring in the developer.

Experiment with chemistry and processes by all means, but never make adjustments to your own proven developing times or methods before testing and verifying them; moreover, make only one parameter change at a time. Similarly, it is always advisable to test a new camera or film prior to going on some extensive trip. Without a developed film to prove that all your photo-systems are 'go', any unproved change could turn out to be costly – conforming to my definition of a mistake: a decision shown only by later evidence to have been wrong. And yet, one still hears sad, frustrating stories of blank films and wasted effort.

Teaching the finer points of exposure techniques is difficult, if not impossible

[3] *Scenes of Wonder & Curiosity,*
Ted Orland; David R. Godine, Publisher, Inc. Boston, MA 2988.

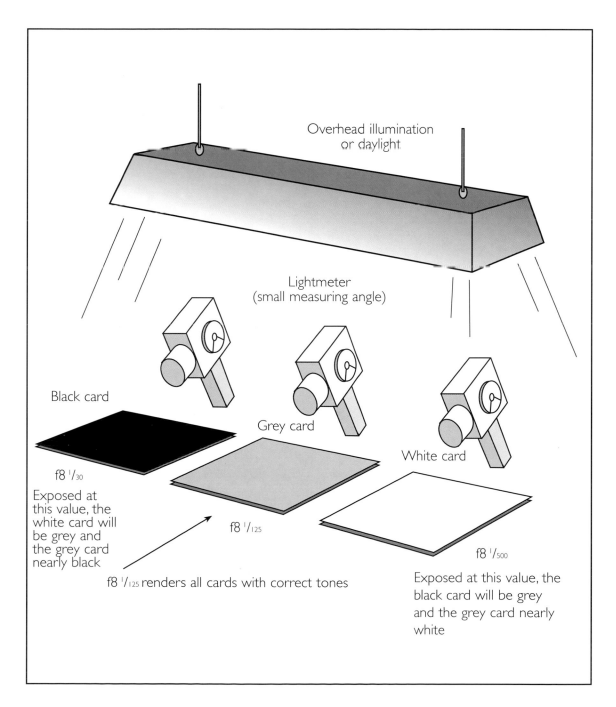

Overhead illumination
or daylight

Lightmeter
(small measuring angle)

Black card

Grey card

White card

f8 $^1/_{30}$

Exposed at
this value, the
white card will
be grey and
the grey card
nearly black

f8 $^1/_{125}$

f8 $^1/_{125}$ renders all cards with correct tones

f8 $^1/_{500}$

Exposed at this value, the
black card will be grey
and the grey card nearly
white

Measuring reflected light

DEFINING PERSONAL FILM SPEED (EI) WITH ONLY ONE ROLL OF FILM

Place a large mid-toned card (preferably Kodak grey) against a wall or on a chair in diffuse *indirect* daylight. Avoid fluctuating sunlight on partly cloudy days. Alternatively, illuminate the target with two 500 watt halogen home security lamps. Position the camera (on a tripod) so that only the target card is visible in the viewfinder. Do not cast a shadow over the target and do not focus: any lens extension will introduce errors. Set nominal film speed, e.g. ASA 100, and measure the light reflected from the target card. (Note: with artificial light aperture settings should be minus ½ f-stop).

The measured value is always middle grey (zone V).
Expose the test film as follows:

Exposure 1. Leave lens cap *on* and advance 1 frame. This is zone 0.
Exposure 2. Set three stops smaller, e.g. f-22, where zone V is f-8.
Expsoure 3. Exposure at zone V setting (f-8 in this example).
Exposure 4. Set three stops wider open, e.g. f-3.5, where zone V is f-8.
Avoid shutter speeds less than ¼ or faster than 1/500 second.
Repeat above steps, resetting film speed ⅓ lower, e.g. 80, 64, 50 (there is probably no point in going higher than the given ASA speed).
If using a 35 mm camera, wind on two more frames and (in total darkness) open back to cut film; the remainder may be needed for more tests. Develop in a hand-tank using recommended times, temperature and agitation. Maintain tank temperature in water jacket ca 2-3 deg. warmer (see illustration). Judge results on a light table by comparing Step 2 against a strip of ND1 neutral density filter, D = 0.3 (or ND2 for 35 mm). The fog + film base (f+fb) of 35 mm film-end offcuts approximate to 1 DN step. Alternatively, use a transmission densitometer to measure the values. Aim for densities of:

Step 1 (zone 0 = fog + film base) D = ca 0.30 on 35 mm; 0,10 on 120 films
Step 2 (zone II) D = 0.25 above f+fb
Step 3 (zone V) D = 0.70 above f+fb
Step 4 (zone VIII) D = 1.25 above f+fb

If results are widely different, adjust development times by 1% per 0.01 density deviation. Alternatively, if negatives are ca 1 stop underexposed, try 20% more development or, for 1 stop overexposure, 30% less development. The main density differences will lie in zones V to VIII.

for users of 'Point & Shoot' cameras, especially when it comes to light metering. TTL automatics make the job a little easier, though their owners are often surprised to find their cameras are downright liars. I ask participants to measure three cards: one black, one grey and one white card lined up in a row, under uniform illumination (see sketch). They see a measurement spread of 5 f-stops, from the black to the white card. A film exposed with the values given by either of the two end cards will render all three cards as various greys in a print The measured light reflected off the grey card would give the correct exposure value; the film would record the black, grey and white properly. This simple test convinces students that a separate light meter gives the best measurement of subject reflectance. It is but one small step toward understanding Adams' system.

The calibration test (see p.40) to establish an EI, or Personal Film Speed can be visually evaluated by comparing the lowest values (in zones I & II) against accurate neutral density filters. A densitometer of course, such as the budget-priced Heiland TRDZ, will give real values of silver density instead of subjective comparisons. Alternatively, one could make a test film contact sheet to assess the results using a Kodak Reflection Density Guide; in each density step is a half inch hole. Placed over the test print, each grey step can be compared through the hole and a density assigned. It should not be difficult to make a similar comparator using an RH Designs Analyser to generate a grey scale.

While DIN (Deutsche Industrie Norm) and ASA film speeds are based on 1/3 f-stop increments, and a good hand-held meter can give readings to 1/6th ISO/DIN, the irony is that the measured values cannot be set on a typical manual camera to better than half f-stop – excepting on large format lenses. With LED's or match-needle systems, as on the old "steam-age" Canon F1, one could judge the between-step settings. Though initially designed for manual metering and a roll film camera, e.g., Hasselblad 503 cx, the film speed test shown here will work for the latest super-electronic cameras with TTL metering systems that set the lens or shutter speed in small intervals. In my opinion, this demonstrates what a compromise it all is.

In an unguarded moment, I once accepted a challenge to explain the Zone System (successfully, and in German to boot!) in one hour to a sceptical professional photographer, something I will not attempt again in a single chapter of this book, even in my mother tongue. There is enough literature on the subject already – some of it, in my opinion, taking things a little too far. In essence, the Zone System is a simple tool that enables you to determine your exposure index (EI) with your development methods, results which might not match the manufacturer's data regarding film speed. This usually turns out two-thirds or even one f-stop lower than the manufacturer's published figures. These figures are defined under laboratory conditions that you may not be able to replicate. But don't take my word as gospel either; do the test and confirm your real film speed.

In acknowledging that camera shutters, lenses and exposure meters are manufactured nowadays to high tolerances, we cannot honestly say our developed films will be within half an f-stop of what was intended. The sequence of physical

events or processes, such as shutter speed, aperture truth, developer temperature, water constituents, etc., includes too many variables. Claims to have devised systems to enable a calibration of the total system (camera, films, developer *and* the photographer) to one sixth of an f-stop are ludicrous. They only serve to turn away people from becoming adept at producing normal, well-exposed negatives.

My message to doubters or the uninitiated is plain and simple: Complete the exposure and development tests shown, define the results as your 'N-0' rating, then go out and do some real photography! The refinements can *and will* come later. Above all, do not get so involved with testing and calibrating films that you become a 'zonie'. These are the ones seen dancing around holding a viewing card (with format shaped hole) as if in some masked ball. Zonies usually take unaccountably boring interpretations of a perfectly good scene. Some never get round to exposing a film because the motif illumination doesn't fit Ansel's Ten Commandments!

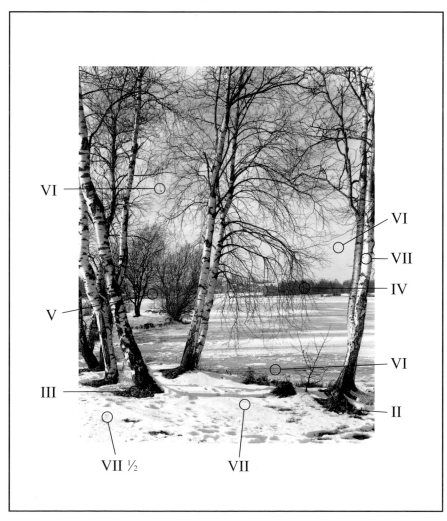

Motif zones in print tones, measured with a Heiland TRDZ Densitometer

On making a word check I found 65 instances of the word 'zone', leaving me feeling that a better title for this book would be 'Confessions of a Reformed Zonie'. After a drastic revamp the score now stands at 38.

If you really want to study the inner workings of film when it has been illuminated by whatever means possible, try digesting the text of Phil Davis' *Beyond the Zone system*. An entrance level guide to photographic sensitometric testing methods, it is a classic among all zone system books. But it is not all theory. Though aimed essentially at the large form user, Davis' book is full of practical tips for darkroom workers – from tailor-made processing tanks to pre-exposure 'flashing' printing techniques with office water-cooler plastic cups.

As a refreshing change from all this technical gobbledegook, I recommend the 'π x wet finger' approach to exercise one's skill at guessing the amount of available light and assessing the exposure values. I once set a workshop class the task of exposing their films (colour negative) not by what the camera meter reckoned, but according to the film data sheet – yes, that little slip of paper that nearly nobody reads! All eight films were properly exposed.

The manufacturer's instructions given with films are centred on the 'sunny 16 rule'. This states: On a bright sunny day at the beach, the exposure at f-16 is 1/ISO number, e.g. 1/125th of a second for a 100 ISO film. These data sheets usually give additional tips on lighting conditions somewhat less than this ideal case. For instance, on a partly cloudy day the recommended setting is minus one f-stop from the 'sunny 16 rule'; no sun, a dull day, minus two stops, etc.

Another way to find the correct exposure is to measure the sun or daylight reflected off the palm of our hands. This would give a value (for Eurasian skin colour) twice as bright as the light reflected from a grey card. In other words, a 36% reflectance value compared with a standard Kodak grey card at 18%. The meter would read f-22, whereas the proper setting is f-16.

Naturally there will be mistakes, but they can happen anyway, even with the best of metering devices. Nobody is perfect, although I do know one professional photographer and Zone System specialist who confidently told me that he had never made a wrong exposure. No comment.

TEST SET-UP FOR FILM CALIBRATIONS

When using artificial light, set up two 500 watt lamps (preferably tungsten halogen, e.g. home security types) positioned 45 degrees to the test card target as shown. Studio lighting (not electronic flash) is also suited to these experiments. Switch off all other light sources, especially neon strip-lighting. Use a lens shade to reduce stray light flare in the camera, as this can affect metering accuracy. When making separate lightmeter readings, take care to limit stray light entering the meter lens.

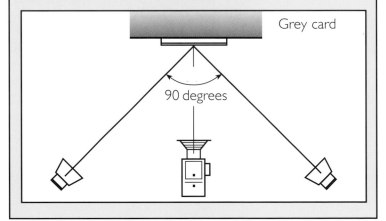

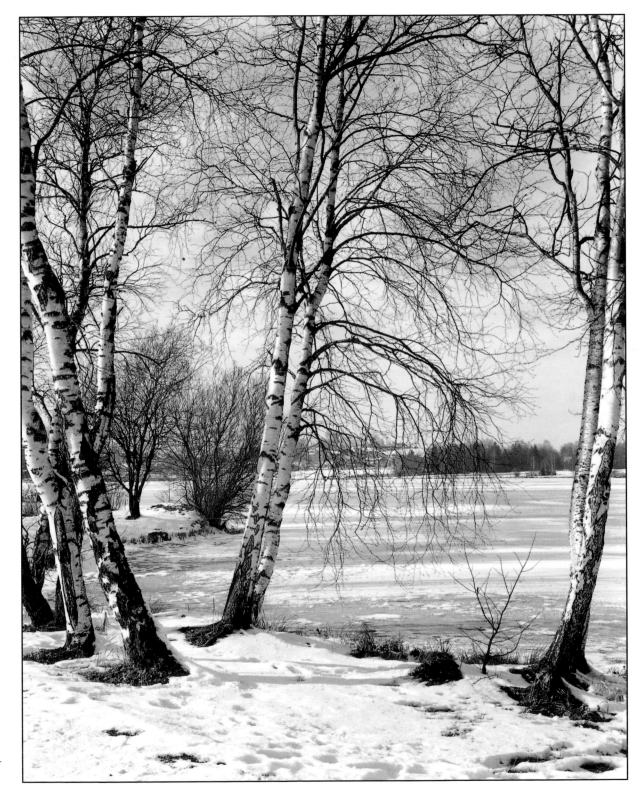

Bavarian Lake in Winter

SEEING THE LIGHT (AND DARK)

COMPOSITION TECHNIQUES I: THE RIGHT VIEWPOINT

Turquoise Trail Shop

If you take route 14 out of Albuquerque – the so-called secret capital of New Mexico – there is a triad of small towns, Golden, Madrid and Cerrillos, made briefly prosperous by gold and coal-mining about a century ago.

Long before the white settlers came in search of this hidden wealth, native Americans had mined high quality turquoise, much treasured in their culture; they had done this for centuries before the Conquistadors arrived. The Spanish rulers forced the natives to mine silver in the 'little hills', Cerrillos, not far from Santa Fé – the old and real capital of New Mexico.

This string of pioneer towns begins a few miles along route 14 at Golden, one of the first places where gold was discovered west of the Mississippi back in 1826. The largest quantity of gold ever dug out of American soil was in Georgia, not in the 'Wild West' as all those gold-rush stories would have one believe.

What followed is classic boom town history. Golden grew, prospered and faded. Now the place is just a ghost of a once-thriving town – at least that's how it felt on a cold January day in 1991, as I walked along the empty highway. The winter silence seemed to emphasise the lost and lonely feeling.

On the edge of town lay a bric-à-brac shop, almost hidden in a small hollow, with a cluster of empty bottles glinting in the sunlight as they dangled on bits of string. A Coca-Cola vending machine leaning a bit on the uneven, snow-covered ground, its classic red paint now faded, completed this archetypal Hollywood film set; a perfect time capsule.

Instinctively, I knew it was one of those one-in-a-million shots. The bitter cold was quickly forgotten in the almost automatic preparations one makes at times like these: Level camera, choose lens, measure light, select filter, set f-stop, etc.

I decided on a full-frontal view at first, with the vending machine playing no significant part in the image design (see frontispiece, p. 7).

For the next shot the tripod was moved a little to the right, placing the vending machine nearer the lens axis and bringing some dynamics into the composition.

The third shot set stronger emphasis on perspective, with the vending machine now more in the foreground and leading one's eyes to the shop front. It was then only necessary to refocus on the machine using the hyperfocal distance technique to ensure a sharp image from six feet to 'eternity' (see panel and photos, p. 44).

I also used the Hasselblad's pre-release button, waiting a moment for tripod vibrations to die away – my standard routine before every exposure. If your camera has a mirror pre-release, this is a habit worth cultivating; a sure way of getting pin-sharp images. The last shot was the best of all three, yet the physical difference between all three different viewpoints was really very small. For an encore, I balanced the Plaubel 67 on top of the Hasselblad viewfinder to make an almost identical image on Fuji RDP. Some prefer this colour version, especially when printed on 16 x 20 inch Ilfochrome Classic. It is an image that works well in either form – even as a hand-coloured picture on Oriental variable contrast fibre base (VC-FB) paper.

On analysing this image further we can again see the Zone System at work. For a snowy motif the range of light was ideal, a good six f-stops. By basing the exposure on recording structure in the shadows and the doorway on middle grey, the brightest sunlit snow fell exactly on zone VIII, while the somewhat dusty snow in the foreground was half a tone lower. I know this last sentence must read like a classic Zone System freak's way of describing the steps before pushing the button, but in truth it simply puts into words what must have gone through my mind during those few wonderful, icy-cold moments in front of the shop.

Four years later, in a much warmer New Mexico springtime, I rode the Turquoise Trail again and stopped in Golden. The Coca-Cola vending machine was no longer there, perhaps sold to a collector. This experience confirmed that one can never, or hardly ever, hope to repeat a successful (or failed) image. Even an old Dodge car (it's in my series *Loved and Unloved*) had gone from outside the shop; normally such things just quietly rust away into the ground. On my last trip to the 'Land of Enchantment', it looked as though the souvenir shop too had gone for ever, the place was so decrepit and overgrown.

Whenever I show my American Southwest collection, the *Turquoise Trail Shop* picture draws the most comments. It has been published many times in photography magazines and calendars. Just a lucky shot in the right place, at the right time; nothing more.

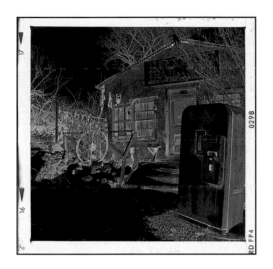

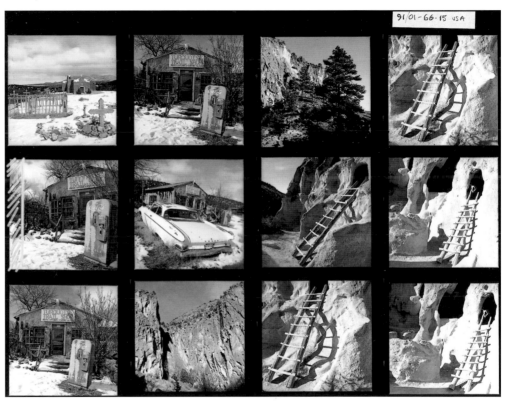

Negative Data
Image: *Turquoise Trail Shop*
Format: *6 x 6 cm*
Camera: *Hasselblad 503 Cx*
Lens: *1:3.5/60mm Zeiss Distagon*
Film: *Ilford FP4-Plus*
Developer: *Ilford Perceptol*

Print Data
Enlarger: *D2 Aristo cold light*
Lens: *Rodenstock 105 mm APO*
Fine print: *Ilford MG IV-FB*
Developer: *Amaloco 6006 1:7*
Toner: *Kodak Selenium 1:20*
Mounted size: *12½ x 14½ inches*

Depth of field controls

Neat little window showing depth of field

Depth of field set to hyperfocal distance

THE HYPERFOCAL DISTANCE

Sharpness in depth is not just a case of stopping down. When a lens is focused on infinity, image sharpness begins near the camera, a distance that is a function of the lens focal length, the aperture and the circle of confusion. This is defined as the 'Hyperfocal Distance'. If a lens can be set to this point, the sharpness will extend from *half* the hyperfocal distance to infinity, or the furthest focused point. A formula gives the basis for defining optimum hyperfocal distance for any lens: distance = $\frac{F^2}{f \times d}$,

where F is the focal length, f the f-stop and \boldsymbol{d} the diameter of circle of confusion. For medium and large formats, the accepted value for the circle of confusion is not more than 1/1000 of the lens focal length. In 35 mm formats, not more than 1/1500 of a standard lens focal length is recommended, equal to a diaphragm opening of 1/750 inch.

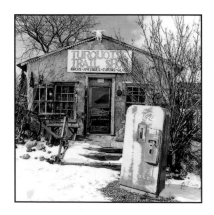

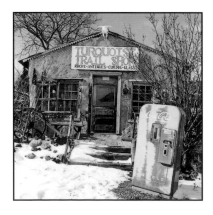

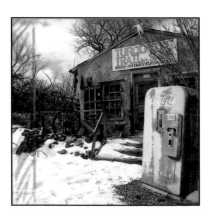

Three views of **Turquoise Trail Shop**

Composition #1

Composition #2

Composition #3

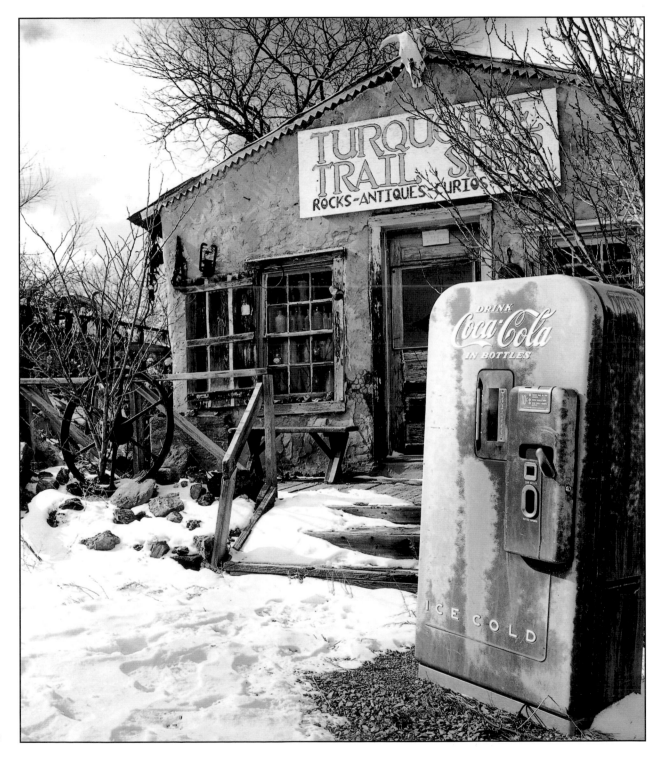

Turquoise Trail Shop

THE RIGHT VIEWPOINT

COMPOSITION TECHNIQUES II:
PERSPECTIVE

A Tale of Two Verandas

Genuine ghost towns are few and far between in the American West. The rest are graffiti-smeared eyesores, or a sad heap of vandalised timber and rubble that would be best cleared away, of little interest except to historians, artists and photographers. Through a lack of detail-maps, many are difficult to find and are often on private land where, they say, people shoot first and ask questions afterwards. It pays to tread carefully, looking out not only for rattlesnakes! Most sites are securely barbed-wire fenced, with signposts indicating that visitors are not welcome.

White Oaks in Lincoln County, New Mexico, was one of the many gold-rush towns that sprang up almost overnight. It soon boasted many fine buildings including a western-style opera, churches, several hotels, four or five weekly newspapers, saloons, dance halls, casinos – and bordellos in a rowdy part called 'Hogtown'. During the first twenty boisterous years of its history, over four million dollars-worth of gold and silver was extracted from the several mines in the neighbourhood. A century ago that was a lot of money. The population quickly rose to around two thousand, though not all were good law-abiding citizens; cattle rustler and outlaw Billy The Kid was often seen around town.

That White Oaks was once such a prosperous town is evident from the number of substantial buildings, many of which have survived the years, and the ravages of mindless vandals. Besides an imposing brick-built schoolhouse, several other buildings still stand in good condition. One of the local mine superintendents, a Mr. Hoyle, built a dream home for an east-coast girl, hoping to attract her out west, but she stayed at home. His classic Victorian-style brick and sandstone mansion, still standing and locally known as 'Hoyle's Folly', must have cost a fortune to build in the 1880s.

Just a few steps away, on a rise near the schoolhouse, the Canning family home still stood in the shade of some fine, tall trees. It must have been an attractive little homestead, but when I saw it first in 1991, the passage of time was beginning to tell. A storm door was hanging off its hinges at a bizarre angle, and broken clapboard panels flapped eerily to-and-fro in the light breeze; an ideal setting for a spooky novel. Approaching the house, I sensed a residual warmth still radiating back through the years to when the old folks sat gently rocking to-and-fro on their veranda.

Behind the house, in an underground cold store, there were bottling jars still standing on the crude shelves, perhaps just as Ma Canning had left them; others lay scattered on the bare soil floor – like a future archaeological dig in the making.

In all three images (on Ilford FP4) the shadowy space under the veranda was left dark to hold the structure visible on the light-coloured clap-boarding. It was the right decision, for the middle values fell easily on the storm door. Though it has less emphasis on perspective, a third shot into the open doorway, with soft shadows on the sun-bleached sides of the house, turned out to be the best image. On the turned-wood column that I so carefully positioned between the two doors in this image, there were traces of a turquoise coloured paint, perhaps signifying some connection with that semi-precious mineral mined in the area – or that old man Canning just liked.the colour.

Revisiting White Oaks in 1996, I found the old house in poor condition though, oddly enough, the door now had a lock on it. During the same tour, I found yet another veranda picture for my collection in northern New Mexico, where a majority of the early Hispanic pioneers established roots. Compared with the Canning's homestead however, this one at La Puenta village was in far worse condition; it was also very thoroughly fenced off. There was only one place in the barbed wire where, with the tripod on maximum extension, a gap allowed a clear view of the veranda – luckily with a strong perspective. As there was no one around to chase me off, and no ominous hissing or rattling, I dragged a rock into position to stand on. If a motif exerts a strong enough attraction, nothing will stop me getting to it. There's nobody worse than a frustrated photographer.

The shadow values deep inside the house, seen through the broken clap-boarding, were down in the film's sensitivity threshold area. According to the meter, a thoroughly uninteresting sky just visible beyond the trees would almost certainly 'whiteout' on zone IX. Under ideal conditions, a powerful fill flash would have been

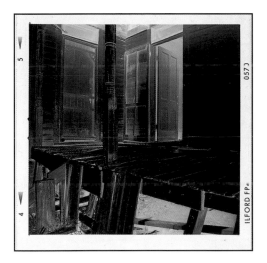

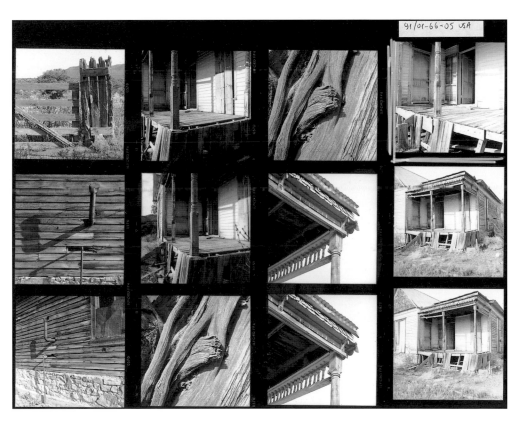

Image Data

Image: Veranda, White Oaks
Format: 6 x 6 cm
Camera: Hasselblad 500 CM
Lens: 1:3.5/60mm Zeiss Distagon
Film: Ilford FP4
Developer: Ilford Perceptol

Print Data

Enlarger: D2 Aristo cold light
Lens: Rodenstock 105 mm APO
Fine print: Oriental VC-FB
Developer: Dektol 1:2
Toner: Kodak Selenium 1:20
Mounted size: 15 x 15 inches

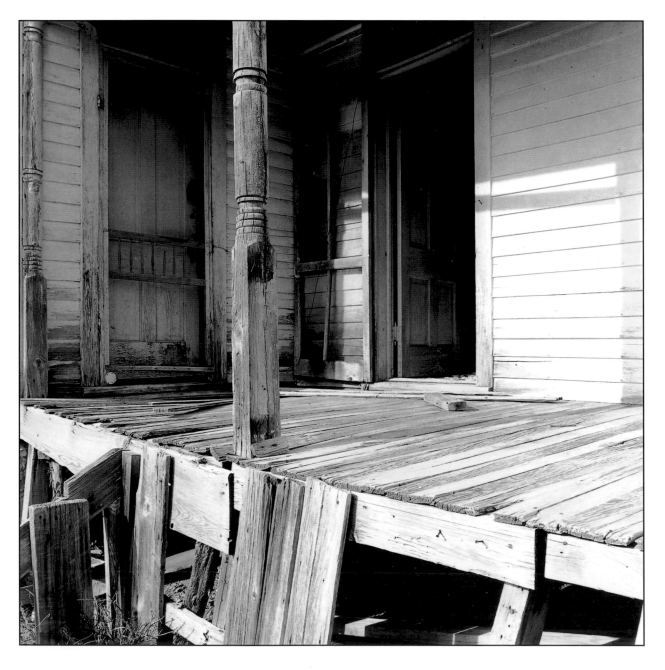

Veranda, White Oaks

the answer to throw some extra light along the veranda and raise it a tone or more. I fired up a Nikon SB-17 twin-flash on full manual and aimed at the veranda ceiling, while directing the small secondary flash toward that dark hole in the wall. To be honest, it had little effect. Nevertheless, the negative prints well on fibre base papers, using the split-grade technique (see chapter 17) with an Aristo cold light source in an Omega D2 enlarger.

While discussing this picture with a photographer friend – comparing a smaller RC version with the exhibition print on Ilford MG IV-FB – he said it seemed to transmit the atmosphere, recreating that dank earthy smell of the mouldy veranda floor (rendered stronger in the selenium-toned fibre base print). I always hope to give each image a sense of presence, a feel of the place; the sound of waves with a tang of salt in the air, or the empty silence of a desert. If a picture can do this it has that vital ingredient for success: the power to stop people in their tracks. At the opening reception of a show where Hotel 1st Floor (chapter 17) was first exhibited, a lady came up to me saying, excitedly, that on seeing this picture she could actually smell burning. Wonderful! at last I had an image that could reach out to other senses.

'There's been a fire!' - chapter 17

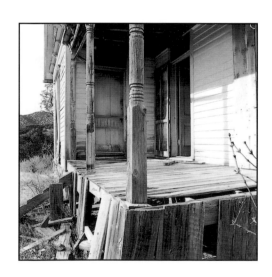

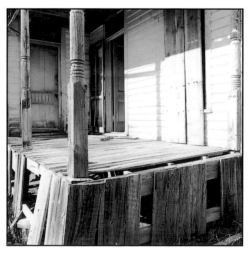

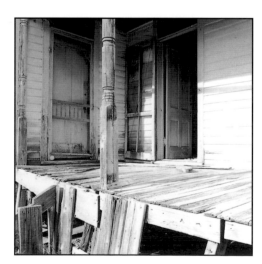

*Three views of **White Oaks Veranda***

Composition #1

Composition #2

Composition #3

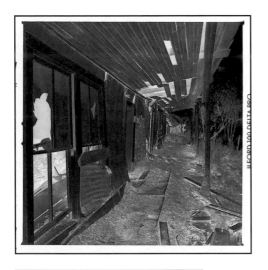

96/09 66-27 USA

Negative Data
Image: Veranda, La Puenta
Format: 6 x 6 cm
Camera: Hasselblad 500 CM
Lens: 1:3.5/60mm Zeiss Distagon
Film: Ilford FP4-Plus
Developer: Ilford Perceptol

Print Data
Enlarger: D2 Aristo cold light
Lens: Rodenstock 105 mm APO
Fine print: Ilford MG IV-FB
Developer: Amaloco 6006 1:7
Toner: Kodak Selenium 1:20
Mounted size: 15½ x 15½ inches

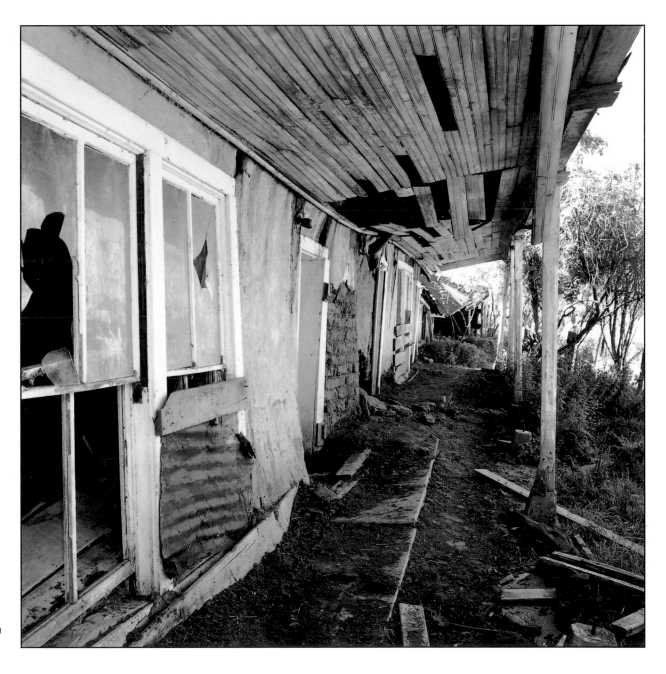

Veranda, La Puenta

COMPOSITION TECHNIQUES III: SKIES AND PESKY MOTES

Morada, El Ranchos de las Golondrinas

Some of the best-preserved examples of the American Southwest's original Hispanic culture can be seen at El Rancho de las Golondrinas, just a few miles south of Santa Fé, New Mexico. In the 18th century, Las Golondrinas (Spanish for the Swallows) was an important stopping place on the Royal Road, El Camino Real, from Nuevo España (Mexico) to Santa Fé. Now Las Golondrinas is a living museum illustrating all the classic elements of a self-supporting *Rancho* of Spanish colonial times. In the modern sense, a 'theme park', but happily without the side-shows and candy floss. With its carefully restored farm buildings, workshops and mills, some of which were originally at Truchas, and a replica of a morada from Abiquiu, there is an abundance of motifs for photographers and artists. Few places in the Southwest paint such an evocative image of a pioneering life and times.

The isolation enjoyed or, more accurately, endured in these old Hispanic villages, especially in the mountainous north of New Mexico, was so complete that it led to the growth of a new chapter of the Catholic Church. Cut off from the religious mainstream, often without the guidance of a resident priest, they gradually developed their own unique form of devotion through lay preachers. The practitioners became known as *Los Hermanos Penitentes*, the Penitant Brothers – a strict covert society vigorously rejected by the official clergy. Despite demands from the Church that they desist, the brotherhood performed their secret rites and religious meetings in a kind of clandestine chapel or lodge called a *morada*. The similarity in purpose to the native American Indians' *kivas* is intriguing. After years of stubborn resistance, during which the brotherhood was persecuted and even outlawed, they were finally accepted into the Roman Catholic Church in 1947. It is said that the brothers still meet undercover, but as the pressures of modern life speed the disappearance of old traditions the *Penitentes* may soon be known only in history books.

There was such a wealth of material at Las Golondrinas, that it became a question of how many films could be spared – and a race against time before the ranch gates closed. Then an unexpected autumn shower put a temporary stop to my motif hunt.

Sheltering under a giant cottonwood tree, I saw the clouds beginning to open up in the northern sky, promising to form a splendid background for what turned out to be the day's best image. By running up to the old *campo santo* (graveyard) there was just enough time to make a few exposures before the skies closed in again for another welcome dust-damping rainstorm. Clouds were scurrying by as I hurriedly searched for the best spot giving a clear view of the bell-tower cross, while checking the changing light with a few spot measurements through a Heliopan # 22 orange filter. But, by placing the shadows on zone III, I knew the brightest parts of those swirling clouds would give me a problem later, in the print. Moreover, it was doubtful whether the clouds would register as envisaged; they were so volatile, varying in shape and tone by the second, leaving little time for contemplation.

However, it turned out that old Murphy had another trick in store for me. On printing a contact set, I saw that a small hair had attached itself to the emulsion, perhaps on loading the film or withdrawing the Hasselblad's dark slide. One of Ted Orland's *Photographic Truths* had been confirmed again: '*Dust spots are attracted to sky areas*' – except that in this case, the result is a white fleck in a print. And as the famous law predicts, naturally, it is the negative with the best cloud formations. White spots in a print are almost as bad as black spots, though, with the former, a reasonable match to the surrounding tones is usually possible using retouching dyes. I recommend the classic paint box kit: two rows of solid dyes, warm tone or cold tone, and *lots* of practice on off-cuts of processed fibre base paper. A good set of retouching brushes is needed too, # 000 to 6, made of red marten hair. A black spot, caused perhaps by a tiny hole in the developed silver, can be treated either in a barbaric fashion, known as 'knifing' with a scalpel, but rarely done without trace, or chemically. The resulting knife 'wound' on the print surface can be hidden under the tiniest drop of clear nail polish delivered with a sharpened toothpick. A minute touch of Tetenal Repolisan, or the finishing lacquer supplied with Polaroid 55P/N will also cover up the damage, but this is another trick that needs much practice.

USA-SW 96-0966/39

Negative Data

Image: Morada El Rancho de Las Golondrinas
Format: 6 x 6 cm
Camera: Hasselblad 500 CM
Lens: 1:3.5/60mm Zeiss Distagon
Film: Ilford Delta 100
Developer: Ilford Perceptol

Print Data

Enlarger: D2 Aristo cold light
Lens: Rodenstock 105 mm APO
Fine print: Agfa MCC 111
Developer: Amaloco 6006 1:7
Toner: Amaloco T-50 1:200
Mounted size: 14 x 14½ inches

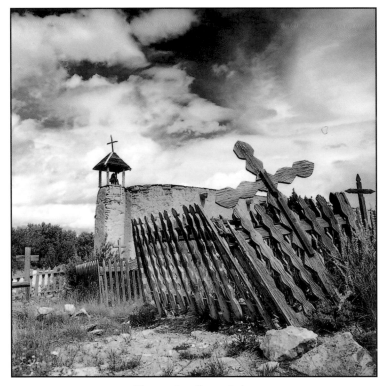

The one I really wanted ...

... before Old Murphy's dirty work

Alternatively, black spots can be completely eliminated by a chemical bleach. This is also a tricky activity, but again there is no short-cut to success – only practice, practice and more practice. A variety of bleaching methods will work, from plain Iodine diluted 1:20 (be careful, it leaves a nasty yellow stain) or Farmers reducer (it also stains), to a touch of Ilfochrome bleach. This is fairly concentrated sulphuric acid, so the effect can be pretty drastic. Adding a touch of thiourea to these bleaches will reduce the staining. Any of these methods, plus a steady hand, a sharpened toothpick, a large magnifying glass (preferably on a stand) and lots of patience, is the best recipe for success. By today's electronic imaging standards, an unwanted blemish in a negative, or positive, is a minor manipulation problem – but this is an area that I dare not get involved with; there are not enough hours in my day.

It was disappointing that such a little hair had so effectively made this a second-class negative. While checking the contact sheet again, I saw that the adjacent image had a better view of the bell-tower, though the clouds are less spectacular and the foreground is not as interesting as the 'hairy' negative. Initially judged to be a compromise, *Morada El Rancho de las Golondrinas* made a strong addition to my collection of American Southwest images.

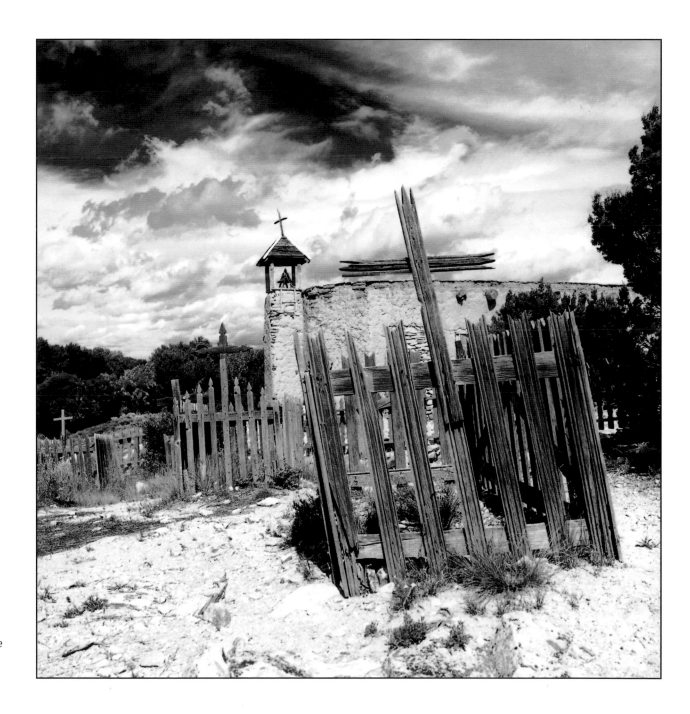

*Morada El Rancho de
Las Golondrinas*

COMPOSITION TECHNIQUES IV: THE FINER POINTS

Signal Box, Spain

Far away from the regular tourist routes, somewhere in northern Spain, this chunky little signal box had once guarded a rural rail-crossing. Like so many other local railway systems, this too had fallen into disuse under the automobile's ubiquitous domination.

Other than knowing it was near one of my favourite wine producing regions, the Rioja, I honestly cannot recall exactly where it was. Perhaps it was the soporific after-effects of an exceptionally good lunch that made me forget to note the spot on our map. With broken telegraph wires dangling above the rusting and overgrown narrow gauge rails, it was the kind of nostalgic image I always respond to – probably a function of my age, my life redolent with memories of the golden days of steam railways.

As I began measuring the subject luminance through a Heliopan # 22 orange filter (for cloud enhancement) the late afternoon sunshine was reflecting strongly from a row of tarred wooden palings in front of the signal box.

With a range of over seven f-stops the resulting light values were too high for comfort. It was a case of accepting that some of the deepest shadows would print black. But why not leave a little to the imagination; is it really necessary to show every detail of a shadowy corner. Must we see into every dark nook and cranny?

At the other end of the tonal scale, a magnificent skyscape of rapidly-growing thunderclouds was giving readings bordering on paper white. This meant placing the important shadow values a stop above threshold so that the brightest billowing cloud would fall on zone VII – a classic Zone System technique. I knew it would need a short burn at a softer grade to restore the original tones.

A further problem was how to render enough three dimensional depth in the scene with a wide-angled lens, when most of the image was filled by the signal box. Switching from the Distagon 60 mm to the standard 80 or 120 mm Planar lens would not have helped – it would have cut out much of that exhilarating sky; in any case, there was a deep hollow behind me. Stepping back for a more distant view was not feasible. There was no other choice of location; the excess of road in the foreground would just have to be cropped in a print. The full-format negative of the

A sturdy enlarger mounting helps.

FILTERS FOR BLACK AND WHITE PHOTOGRAPHY

Filter (Wratten #)	Description	Effect
# 2A (UV, pale yellow)	Absorbs UV radiation below 405 nm	Haze reduction
# 8 (yellow)	Absorbs some blue light	Improves landscapes, skies and clouds; texture too
# 12 (medium yellow)	Moderate blue absorption	Increases contrast, darkens blue sky
# 15 (deep yellow)	Absorbs almost all blue light	Darkens sky, enhances clouds, reduces haze
# 22 (orange)	Absorbs almost all blue light and emphasises red	Greater darkening of sky; renders improved contrast
# 25 (red)	Transmits red light; absorbs almost all blue and green light	Lightens red coloured objects or scenes; renders sky very dark, greatly reduces haze
# 47 (blue)	Transmits blue light; absorbs almost all red and green light	Increases haze; lightens any blue coloured subjects
# 58 (green)	Transmits green light; absorbs almost all blue and red light	Lightens anything green, such as leaves, grass etc.
Polariser	Absorbs light rays at certain angles	Reduces reflections from non-metallic surfaces: water and glass. Darkens sky in 90 degree sector from sun
Neutral density (ND)	Reduces light in graded steps from 0.01% (ND 4) to 80% (ND 0.1)	For accurate control of light and/or exposure settings

CONVERSION TABLE

Heliopan/Kodak	Hoya	B&W
# 2A (UV)	UV (0)	010
# 8 (yellow)	-	021
# 12 (medium yellow)	K2	022
# 15 (deep yellow)	Y52	023
# 22 (orange)	G	040
# 25 (red)	25A	090
# 47 (blue)	-	081
# 58 (green)	X1	061

A grain focuser is one of the best accessories

original motif before the work print stage, and the subsequent format is seen on p. 59 and 61.

Aside from all these semi-technical considerations, I honestly cannot recall thinking about the often quoted 'fundamental rules of composition': the golden section; rule of thirds and other formal limitations. Such constraints are made to be broken, something I consistently do – though not to be deliberately awkward. This was a composition not concerned with precepts, but rather an image design that just fell into place intuitively (that word again!) while I set up the gear.

In an essay on pictorial art, John Constable (1776-1837) wrote of the importance of skies in composition: "The landscape painter who does not make skies a very material part of his composition, neglects to avail himself of one of his greatest aids. It will be difficult to name a class of landscape in which the sky is not the key note, the standard of scale and the chief organ of sentiment." These elegant words can also be applied to landscape photography, as Ansel Adams demonstrated so well in his magnificent images of the American West. Adams's famous 'Clearing Storm' must surely have inspired many a lesser mortal to take similar snapshots; I still marvel at the immense tonal range of that image.

Unfortunately, clouds can be quite capricious. Usually, just as I've found the best spot for the tripod, made all the necessary light measurements, checked and rechecked the composition and focus, one of these delightfully fluffy bundles of moisture decides to cover the sun's face! Incredibly, this happens frequently – sometimes signalling an end to the day's photography.

People frequently comment on the lack of spots on my prints, either from retouching or simply as blemishes in a lighter part of the image, generally in the sky, of course. I try to assure them that there is no magic involved; just lots of patience. If it takes me ten minutes to clean a negative, to remove the last speck, repeatedly 'puffing' with a little rubber bulb, then so be it. A photographer friend in Alabama had a large bulb from an enema kit, he said, that issued a truly massive blast of air. You may get a few strange looks on asking for one of these in a surgical appliance shop, however! In more persistent cases, something stuck on the negative surface for instance, a gentle wipe with Kodak Film Cleaner will usually do the trick. It (Heptane) dries rapidly and will not attack the emulsion surface. The cleaner should be applied with small pads of fine cotton wool such as used by eye specialists; it is a job best done on a *scratch free* light table.

The darkroom worker's worst enemy is dust, those pesky particles or 'foreign bodies' that attach themselves easily to the films, or to one or both sides of a negative carrier. Ergo, if the darkroom needs a clean-up, I would sooner wait until a current project is finished, rather than stir up dust with the vacuum cleaner. Why ask for trouble? Smokers have an additional problem: cigarette ash on their person or clothes.

Though glassless negative carriers are standard equipment in my darkroom for most formats, I must admit that glass carriers are the only way to cope with 5 x 4 inch negatives, especially a thin Polaroid 55P/N film. Burning at 200 watts, the lamp in my LPL 7451 colour enlarger produces enough heat to make a mounted 35 mm colour slide 'pop', as in slide projectors. But, by switching the lamp on and watching the image through a grain focuser for say thirty seconds, it will be seen to return to its pre-focused position. On the other hand, my Omega D2 – used exclusively for black and white work – keeps its focus well, the Aristo cold light being cool in more than one respect.

To avoid this happening while printing with the LPL, I cap the lens and switch on, to let the negative or positive warm up while positioning the paper in the easel. When all is ready, I very carefully remove the lens cap while switching off and on again as quickly as possible. If there is space in the filter drawer, a piece of infra red blocking glass might help prevent the image buckling. I used to think of this pre-warm trick as a typical Todd compromise, until I read the same tip in Ctein's unique book Post Exposure [4] – a more illuminating and scientifically penetrating handbook for the serious darkroom worker, by the way, would be difficult to find.

People often remark on the sharpness of detail in my prints. I believe this comes not only from the quality of lenses, films and developer employed, but also from a stable enlarger mounting, a critical factor often overlooked. Two of my enlargers are mounted on 3/8 inch thick aluminium plate (see p. 56) and anchored at the top by a steel bracket firmly fixed to the wall. Lastly, I never trust my now ancient eyes to focus the image on an easel unaided. A grain focuser is one of the best accessories for the serious darkroom worker; buy the best you can afford. I have an Omega Grain Focuser with a swing-optic, ancestor of the current Peak models.

[4]. *Post Exposure, Ctein; Focal Press, Woburn MA 1997*

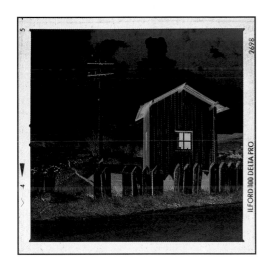

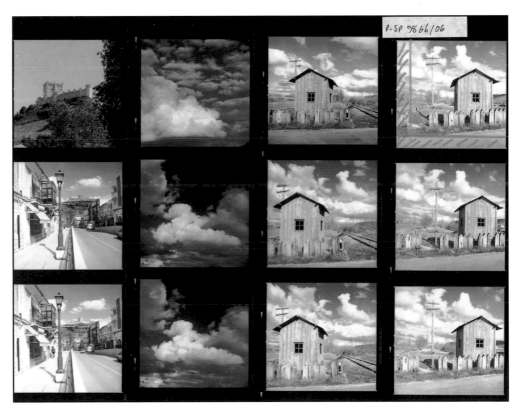

Negative Data
Image: Signal Box, Spain
Format: 6 x 6 cm
Camera: Hasselblad 500 CM
Lens: 1:3.5/60mm Zeiss Distagon
Film: Ilford Delta 100
Developer: Ilford Perceptol

Print Data
Enlarger: D2 Aristo cold light
Lens: Rodenstock 105 mm APO
Fine print: Ilford MG IV-FB
Developer: Amaloco 6006 1:7
Toner: Kodak Selenium 1:20
Mounted size: 15 x 15½ inches

"It will be difficult to name a class of landscape in which the sky is not the key note, the standard of scale and the chief organ of sentiment."
John Constable

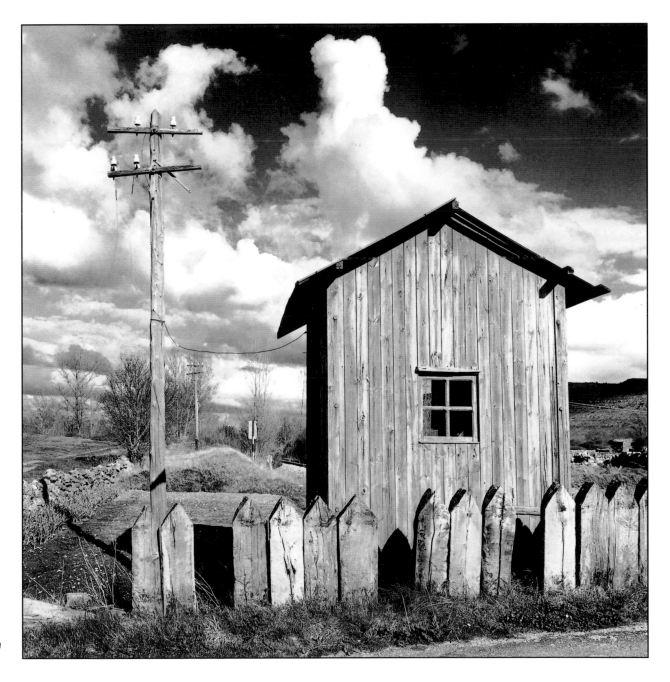

Signal Box, Spain

OUR VILLAGE

Informal Portraits

When I moved in 1972 to Hochstadt, a typically Bavarian village about twenty miles south west of Munich, there were over two dozen family-run dairy farms, a population of 500 people and about as many cows. With individual farms working widely scattered feudal-like strips of land outside the village, this compact community was another world, far removed from the English manor farms I was familiar with.

Traditionally, Bavarian farms are centred on a large house, with the family living space at one end of the building and the cows tethered in stalls at the other. Over the years, the number of active farms has dwindled; now only five are still operating, albeit with a larger stock.

It was the realisation that an idyll was fast disappearing that moved me to begin a record of village life, especially the various trades and crafts. On my retirement in 1990, the first action was to draw up a plan listing the person(s), village activities and possible lighting requirements.

Like so many other good intentions, I had thought for years about photographing the interior of our 'Aunt Emma' corner store, the only village shop. Then it closed for the last time. That was the catalyst. It was now or never, especially as some of the older village personalities had already passed away.

Farmer Kreitmeyer & Son is one of the earliest pictures in 'The Hochstadt Collection'. I just happened to walk by at the right moment with a Hasselblad loaded with FP4 and a Metz 45 flash unit hanging over my shoulder in case I needed some extra light (which wasn't necessary). They posed quite spontaneously by the barn door, giving me time to make nine frames.

Looking back at this image now, I can see a similarity with August Sander's pictures of German working-class or professional people, images he made in the between-war years – or with Stephan Moses' more recent oeuvre. Though the influence of Sander is unmistakable in this picture, it just seemed the natural way to catch an informal portrait of a farming father and son at work.

I was not the only one pleased with this image, for old Kreitmeyer died a short while later. Soon afterwards the family cleared his orchard (shades of Chekhov!)

and built a fine new house. No one would know there had ever been a farmhouse or a barn there.

Sepp the Sexton made a classic picture as he rang the church bells – a job he had done morning, noon and evening every day for the past forty years. This time it was a pre-arranged picture. I used a Hasselblad SWC camera, its wide-angled distortion free 38 mm Zeiss Biogon lens easily coping with the cramped, unlit space behind the altar. To boost the available light, I placed two tungsten lamps each side of the altar, angled to bounce light off the white walls, with the stronger lamp behind me to ensure that Sepp's face would be lit (see illustration). Ilford HP5 rated at EI 200 was ideal for this image, while a 1/8 second shutter speed was enough to blur the action. It was difficult, however, to synchronise each shutter release with either a 'ding' or 'dong'.

Normally the ringing seems to go on and on – especially at a rude 6 a.m. But just as Sepp stopped pulling on the ropes, I also finished the twelfth shot. Happily, two of the images worked out as envisaged; it would have meant waiting another day, or longer, for a rerun. I was not aware, however, that it had been almost the last chance to see this regular happening. A few days later the bells were silent for several weeks while a local contractor installed an electronic ringing mechanism on the old bells.

While prying around the local carpenter's yard, I met a couple of 'Vogtlander Journeymen'. As fully-fledged apprentices, qualified in trades such as metalworking, stone-masonry and carpentry, they travel from master to master as in olden-times, gaining experience not only of their hand-worker's craft, but also of life. Carrying their worldly goods in a bundle called a 'Charlotte' slung over a carved vinestock, journeymen (more rarely women) pledge in solemn, secret rites to be on the road for two years and one day. They cannot stay longer than three months in any one place, be within fifty kilometres of their hometown, or use public transport. Their distinctive dress of black corduroy jackets, wide-brimmed felt hats and bell-bottomed trousers decorated with large pearl buttons, gives them a unique medieval appearance.

Negative Data
Image: Kreitmeyer & Son
Format: 6 x 6 cm
Camera: Hasselblad 500 CM
Lens: 1:5.6/120mm Zeiss Distagon
Film: Ilford FP4 Plus
Developer: Ilford Perceptol

Print Data
Enlarger: D2 Aristo cold light
Lens: Rodenstock 105 mm APO
Fine print: Oriental VC-FB
Developer: Agfa Neutol WA 1:7
Toner: Kodak Selenium 1:20
Mounted size: 12½ x 14 inches

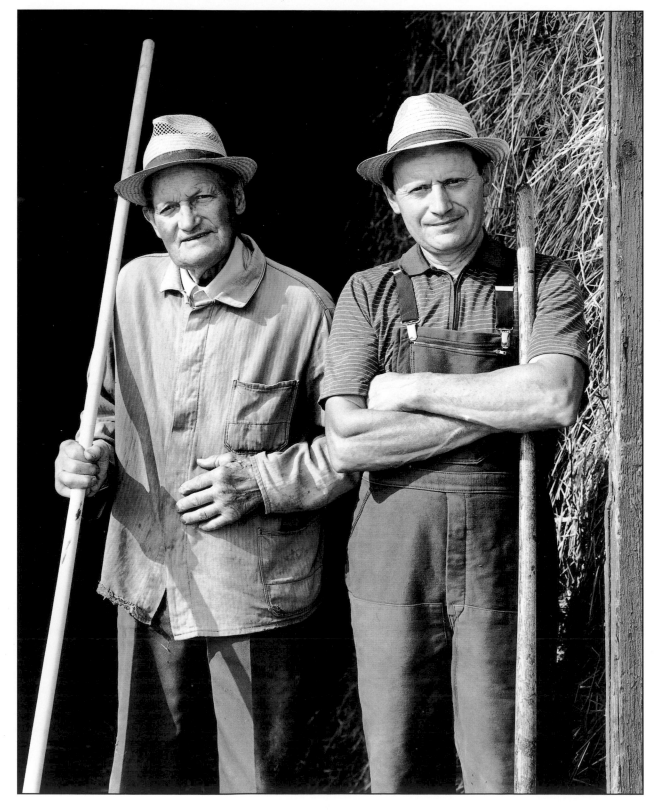

Kreitmeyer & Son

Lighting layout for 'Sepp the Bellringer'

Hassselblad SWC

Heiko the Journeyman was clearly anxious to get back to work, so I had to move fast for this portrait – there was no time for the finer points, and nothing I could do about the shadow across his face from that wide-brimmed floppy hat. I measured the lighter side of his face and set the aperture one stop above middle grey. Just before triggering the shutter, I angled the Hasselblad dark slide toward the sun to flash a highlight in Heiko's eyes.

Normally, in professional outdoor modelling or portrait sessions, one uses reflectors to add a stop or two of fill-light – or black shades to subtract light and reduce the contrast range. But I liked the hat shadow; it gave him a kind of Western tough-guy look, quite the opposite of the love-torn hero in a Lieder Cycle about a Journeyman by Gustav Mahler translated so oddly as Songs of a Wayfaring Lad.

The Hochstadt village project is now over ten years old and totals hundreds of images on a wide range of films – from Ilford XP1 and 2, FP4, HP5 and DELTA to some rare shots on Tri-X, T-Max or Fuji Neopan. There is also an enormous archive of colour slides, in 35 mm and medium formats that lie forgotten in the files. Except for a few chromogenic films (XP1 & 2), the majority were developed by hand in a small tank filled with one or other of the standard Ilford developers.

Initially, I developed a few XP1 films in original Ilford chemistry using a Jobo ATL-2 Autolab, but there was nothing to choose between my own processing and that of a 'one-hour' colour negative photo-finisher – who was at least cheaper and time-saving. But a word of caution. Two of these professionally developed XP1 films later 'grew' some strange orange spots on the image surface, possibly due to stale or insufficient stabiliser. This contains a small percentage of formaldehyde to prevent bacterial growth. Perhaps Adams was right to doubt the lasting qualities of chromogenic films, compared with a properly processed conventional film. With this in mind, it might pay to make silver duplicates of a valuable image.

On a more positive side, these 'silverless' films (a misnomer really; like all other films they start out life with a silver-halide emulsion) are capable of producing superb quality monochrome negatives. I encourage new recruits to photography to use one or other of the chromogenic films, XP-2 plus or Kodak CN 400. These films will give good results most of the time owing to the immense exposure lattitude and are ideal for getting to grips with basic techniques in 'seeing' and composition. Additionally, most finishing labs are not averse to making contact sets (now called Index Prints again, as they did 100 years ago) and 'N-prints' on colour paper that give the picture a kind of attractive old-timer sepia tint. Investment in a small darkroom is not so pressing at this stage of the photography thing – the obsession follows.

Negative Data

Image: Sepp the Bellringer
Format: 6 x 6 cm
Camera: Hasselblad SWC
Lens: 1:3.5/38mm Zeiss Biogon
Film: Ilford HP5
Developer: Ilford ID 11

Print Data

Enlarger: D2 Aristo cold light
Lens: Rodenstock 105 mm APO
Fine print: Ilford MG IV-FB
Developer: Agfa Neutol WA 1:7
Toner: Kodak Selenium 1:20
Mounted size: 9 x 14 inches

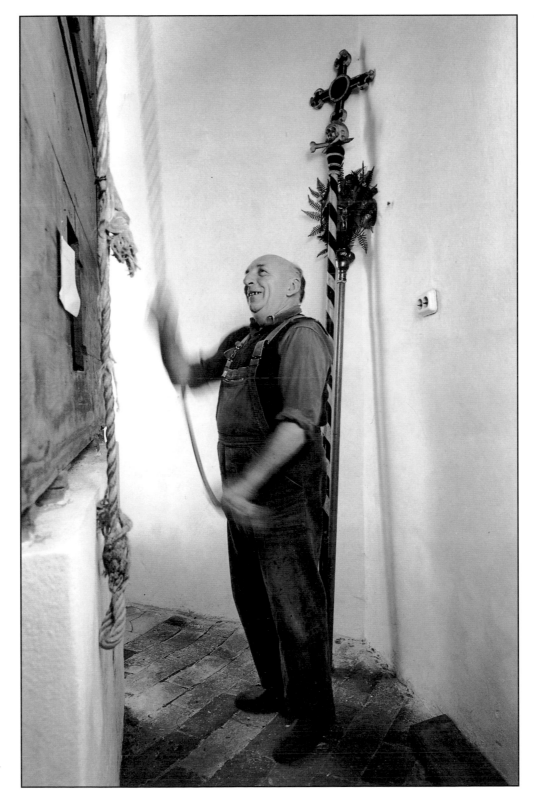

Sepp the Bellringer

Negative Data

Image: Heiko, Journeyman
Format: 6 x 6 cm
Camera: Hasselblad 500 CM
Lens: 1:5.6/120mm Zeiss Planar
Film: Ilford FP4 Plus
Developer: Ilford Perceptol

Print Data

Enlarger: D2 Aristo cold light
Lens: Rodenstock 105 mm APO
Fine print: Oriental VC-FB
Developer: Agfa Neutol WA A:7
Toner: Kodak Selenium 1:20
Mounted size: 12 x 10½ inches

Heiko, Journeyman

STILL LIFE SUBJECTS
Variegated Lady

Aficionados of Tuscany dream of olive groves and vineyards, and wave upon wave of voluptuous green and ochre-coloured hills lined with tall dark trees, or the Maremma's golden beaches – and mysterious Elba across the ever-changing sea. But away from the tourist brochure and picture book image, this venerable land still shows its Etruscan origins; even the name Tuscany is derived from Tusci, the Latin name for the enigmatic first settlers.

In the stumpy volcanic hills inland, many of Tuscany's ancient villages are built like fortresses – the inhabitants needed strong walls to defend themselves against sea-raiders and rapacious armies led by medieval warlords from Sienna or Pisa. I went in search of this fascinating land, tracing the footsteps of Giosuè Caducci, Aldous Huxley and D. H. Lawrence armed not with a pen, but a Hasselblad 503 cx, a range of lenses, plus a hundred rolls of Ilford FP4 and Delta 100 with enough developer to last a winter's stay.

On one of my daily sorties in search of images, I ventured into an old wine estate, or 'Tenuta'. The imposing coat of arms decorating the house wall showed it had been the seat of a prominent Tuscan family, perhaps a Dukedom in Renaissance times.

After asking permission to photograph in and around the grounds, I started with a formal tree-lined drive where two marble stairways led up to the manor house and its elegant boulevard. There, entwined in ivy and silently mourning times past, *Variegated Lady* posed for her portrait in the cold January air.

In one of the barn-like buildings there was a row of ancient wine presses, while another barn contained three Alfa Romeo sports cars covered with years of dust, their tyres flat to the rims – all difficult, available light subjects. I had just managed to record this extraordinary sight, when a shout from behind indicated that my welcome was beginning to wear thin. It was time to go!

With a density range of D = 1.3 above f+fb, *Variegated Lady* is a delightful image to print. When I made this negative the deepest shadow values lay under the ivy, with a zone VII 1/2 highlight on the statue's shiny head. This should have been correct for my normal development of FP4: fifteen minutes in Perceptol 1:1

dilution. The darkest tone turned out just half a stop above base fog; a touch longer exposure (or a little more development) might have given better resolution in the shadows.

As a result, the sky and the statue's arms and head need some additional exposure when printing this image; a softer grade filter does the trick. Luckily, the sky was fairly bland at the time, being about the same reflectance as the statue's highlights, though in retrospect I would have preferred better tonal separation between the sky and statue. Picturesque clouds, on the other hand might have detracted from the isolation of the figure from its background which I kept sufficiently out of focus. This was done by setting the Hasselblad's 60 mm Distagon f-stop to give just enough depth of field using the hyperfocal distance method (see p. 44). My favourite print of this image (on the wall behind me as I write) is on Ilford Multigrade IV FB processed in Amaloco chemicals: 6006 developer, S10 citric acid stop and X88 neutral fixer. It was finished in T-50 selenium at 1.20 dilution for stability only, giving a max D of 2.20. At this strength, by the way, it cannot be stored for later use; dilutions of 1:3 to 1:9 will keep for up to 6 weeks in a full container. Likewise, Kodak Selenium Toner should only be stored at the stronger dilutions. A quick squirt of Tetenal Protectan will expel air out of the container and help to keep the chemicals fresher longer.

The full-format negative, top of the group on p. 70, contains a little too much of the stone balustrade. In the cropped version the viewer's eyes are directed towards the statue's head, with the low-angled view placing fuller emphasis on the statue. A view through the railings to a distant farmhouse adds an unintentional diversion. One big advantage of a square image is that you can photograph more than is needed, and adjust the composition later while printing. I call this darkroom activity re-visualisation. The pictures on p. 70 show the full negative format in an uncropped print.

Cropping continues to be a thorny subject, but for those who follow the 'compose only in the viewfinder' philosophy, I offer the following: First, it is not always possible to place a tripod exactly on the ideal spot; there is usually something in the way, like a tree in the immediate foreground – or the sea lapping round the tripod's legs! Secondly (studio photography excepted), subjects rarely fit a focusing screen or film format as visualised, and vice-versa, so why object to cropping? Show me an artist limiting the scope of his or her paintings to one size and shape of canvas; a ridiculous idea. However, in direct contrast to the above remarks, the best of my 6 x 7 negatives embody the whole motif as initially visualised. Truly a Whitmanesque contradiction!

Statues make excellent study subjects which help us to understand the moulding properties of daylight at different times of day. Claude Monet painted a series of canvases at Rouen Cathedral to show the changes in colour as the sun moved around the sky; an experiment easily repeated photographically.

The changing seasons – a soft blanket of snow or the gloss of rain – can also bring a new slant to the way we see quite ordinary things. Best of all, with a statue there are no model fees to pay, although one might have to be careful if the sculptor is still living. In the former DDR, I found a very shapely bronze with highly polished breasts that reflected not only the sunlight, but also a different kind of practice put in by local admirers! The shine certainly added another dimension to a fascinating subject.

In a Tuscan Tenuta

Variegated lady, marbled toes leafed in ivy;
why those frosted tears flowing down your
patinated breast? Is it the metallic winter's cold.
Do you grieve for times past; a season's soirée,
Tuscan gentility tête-à-tête on your balcony.
or was it another's weeping, barely heard

as the greaceful house emptied,
its great gates slammed shut in
the face of fading hopes,
when the vines died.

Now, where silky Arabs once slept,
the Padróne's Alfas lie unloved
and flat-footed - sequestered in
Time's dusty amnesia.

George E. Todd

Negative Data

Image: *Variegated Lady*

Format: *6 x 6 cm*

Camera: *Hasselblad 503 Cx*

Lens: *1:3.5/60mm Zeiss Distagon*

Film: *Ilford FP4 Plus*

Developer: *Ilford Perceptol*

Print Data

Enlarger: *D2 Aristo cold light*

Lens: *Rodenstock 105 mm APO*

Fine print: *Ilford MG IV-FB*

Developer: *Amaloco 6006 1:7*

Toner: *Kodak Selenium 1:20*

Mounted size: *14 x 16½ inches*

Variegated Lady

AVAILABLE LIGHT INTERIORS

Las Trampas, New Mexico

Along *El Camino Alto*, the old high road between Santa Fé and Taos, there are several villages dating back to Spanish colonial times. In historic Truchas, with its splendid views of the Sangre de Cristo Mountains, one can still sense the charm of an older, maybe more settled, world. This mainly agricultural community, descendants of those hardy Spanish pioneers, numbered a few hundred in the mid-19th century. Now there are just a few surviving families. Newcomers from both sides of the language divide are renovating the old homesteads, a trend that at least ensures the village's very existence against further decline.

A few miles away, the tiny community of Las Trampas was enjoying the quiet of a siesta as I strolled into the dusty plaza – once a quadrant enclosed by single-storey houses. The distant sound of music attracted me to the open doors of San José de Gracia church. As my eyes adjusted to the darkness, I could see someone playing a small harmonium in a far corner of the church. Though I had clearly interrupted his musical musings, the warden welcomed the opportunity to talk about the old church, its remarkable interior and local history. With its eight beautifully painted altar panels and twenty-five huge, hand-adzed ceiling beams or 'vigas', each resting on a finely carved buttress, it was reminiscent of older churches I had seen in the high Sierras of Spain.

Like so many churches in these parts, San José de Gracia had also served as a kind of fortress. If raiding bands of Comanche or Apache were seen in the vicinity, Las Trampas villagers could flee into the building via a pull-up ladder to a balcony, the original entrance above the present doorway. The rickety old floor-planking is said to cover a crypt containing sixty-four tombs of early settlers. It was, as the warden explained, used initially as a temporary place for the dead when the ground outside was too frozen to dig. Winters in northern New Mexico can be very harsh.

We chatted for a while then he allowed me to photograph the interior using a tripod, for which I was more than happy to push a few dollars into the offertory. Thanking me, he reflected sadly that most visitors 'glance quickly around, take a few snaps with a pocket camera (the kind that switch automatically to flash in dark interiors) then go'. When asked to desist, some just continue shutter-clicking and leave noisily 'without putting so much as a cent in the box'.

Revisiting Las Trampas in the autumn of 1996, I met him again still sitting-in as the church warden. He was not so pleased to see visitors anymore, especially the pocket camera types. Owing to the ever-increasing numbers of visitors, religious or otherwise, he said the custodians were considering banning photography altogether in the church – perhaps keeping it closed at all times except for regular Holy Mass. Theft is a universal problem and the reason why so many village churches are keeping their doors closed, as has also happened in Europe. Since I wrote this, the only pictures of Las Trampas you can take away are postcard souvenirs sold to make a few pennies for the church.

Somehow I cannot resist dimly lit interiors – they always present a challenge: how to make the best job with a minimum of subject illumination. Another of Orland's Photographic Truths states: 'Available light won't be', and the interior of San José de Gracia certainly fitted this profound belief. It needed a time exposure of such long duration, I was scared that someone might walk in and shake those creaky old floorboards while I was counting off the seconds. The problem was made worse by positioning the camera and tripod, and myself, in the entrance, effectively blocking a substantial amount of the barely available light.

To offset a possibility of underexposure in the shadows (due to reciprocity failure) I moved zone V up two f-stops to compensate for my standard development; there were other normally exposed latent images on this film. It's a fudge, I know, but it does work. So, while a sticky shutter stuttered to a halt (some four seconds instead of one) giving a kind of built-in exposure correction, I knelt behind the door – not to pray, but to add an extra stop of light. That old Distagon shutter needs fixing, one day.

San José de Gracia, Las Trampas was easy in comparison with the cave-like darkness in San Miniata on the hills above Florence. For some reason there was nobody around to stop me using a tripod, which was just as well, for even with a bean bag it would have been a difficult, if not an impossible task. I wished for a flashlamp to see the camera settings, it was almost too dark to focus it properly, and compose the scene without falling lines. The light was so minimal (less than EV 5 in the highlights!) that I

Negative Data

Image: Interior, Las Trampas
Format: 6 x 6 cm
Camera: Hasselblad 503 Cx
Lens: 1:3.5/60mm Zeiss Distagon
Film: Ilford FP4-Plus
Developer: Ilford Perceptol

Print Data

Enlarger: D2 Aristo cold light
Lens: Rodenstock 105 mm APO
Fine print: Ilford MG IV-FB
Developer: Amaloco 6006 1:7
Toner: Kodak Selenium 1:20
Mounted size: 11½ x 12 inches

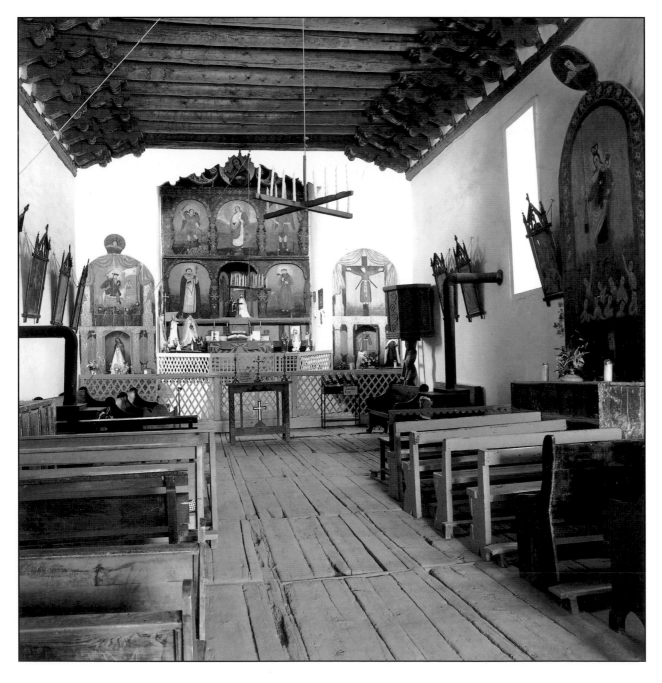

Interior, Las Trampas

APERTURE AND SHUTTER COMBINATIONS IN EV OR LIGHT VALUES

EV#	f2	f2.8	f3.5/4	f5.6	f8	f11	f16	f22	f32
					(times in seconds)				
1	2	4	8	16	32	64	132	264	526
2	1	2	4	8	16	32	64	132	264
3	1/2	1	2	4	8	16	32	64	132
4	1/4	1/2	1	2	4	8	16	32	64
5	1/8	1/4	1/2	1	2	4	8	16	32
6	1/15	1/8	1/4	1/2	1	2	4	8	16
7	1/30	1/15	1/8	1/4	1/2	1	2	4	8
8	1/60	1/30	1/15	1/8	1/4	1/2	1	2	4
9	1/125	1/60	1/30	1/15	1/8	1/4	1/2	1	2
10	1/250	1/125	1/60	1/30	1/15	1/8	1/4	1/2	1
11	1/500	1/250	1/125	1/60	1/30	1/15	1/8	1/4	1/2
12	1/1000	1/500	1/250	1/125	1/60	1/30	1/15	1/8	1/4
13	1/2000	1/1000	1/500	1/250	1/125	1/60	1/30	1/15	1/8
14		1/2000	1/1000	1/500	1/250	1/125	1/60	1/30	1/15
15			1/2000	1/1000	1/500	1/250	1/125	1/60	1/30
16				1/2000	1/1000	1/500	1/250	1/125	1/60
17					1/2000	1/1000	1/500	1/250	1/125
18						1/2000	1/1000	1/500	1/250

Note: the EV system allows you to set and select a combination to suit the situation, e.g. with less depth of field at fully open aperture, or with the same light value and greater depth of field by a moderate f-stop. Automatic camera programmes are generally based on this system. Exposure times longer than one second require adjusting to account for reciprocity law failure. This correction varies according to the type of film used, but can be of the order as shown below:

Meter indicated time (seconds)	Adjusted time (seconds)	OR aperture adjustment of ...
1	2	plus 1 f-stop
10	50	plus 2 f-stops
100	5 minutes	plus 3 f-stops (perhaps more)

almost gave up the idea. Happily, the Pentax V Spotmeter display has internal illumination for occasions like these, making it just possible to see the light values. According to the meter, a one minute exposure was about right for the estimated depth of field – it was too dark to focus accurately.

Taking reciprocity law failure (see chapter 2) into account, I figured that around five minutes might be a more realistic exposure time, but compromised in my usual 'wet finger in the air' way with three minutes for another longer than appropriate development. The film (FP4 Plus) had been rated at 80 ISO for the other images hidden in its gelatine. Developed in Perceptol 1:1 for fifteen minutes at 20° C, it resulted in a rather thin negative, but when printed on Ilford Multigrade IV FB at grade 4½, it has a remarkable range of tones – especially those marble columns, which actually appear to be round. There is even detail in a small window high up on a back wall of the building.

I had just finished packing the camera and tripod when a posse of police, *carabinieri* and various important looking people came into the church heading straight for the rear part of the altar. It was clear now why the place was deserted while I took this picture; the guards had been waiting outside for the VIPs. Luck had been with me for once.

Negative Data
Image: Interior, San Miniata
Format: 6 x 6 cm
Camera: Hasselblad 503 Cx
Lens: 1:3.5/60mm Zeiss Distagon
Film: Ilford FP4-Plus
Developer: Ilford Perceptol

Print Data
Enlarger: D2 Aristo cold light
Lens: Rodenstock 105 mm APO
Fine print: Ilford MG IV-FB
Developer: Amaloco 6006 1:7
Toner: Kodak Selenium 1:20
Mounted size: 12½ x 14½ inches

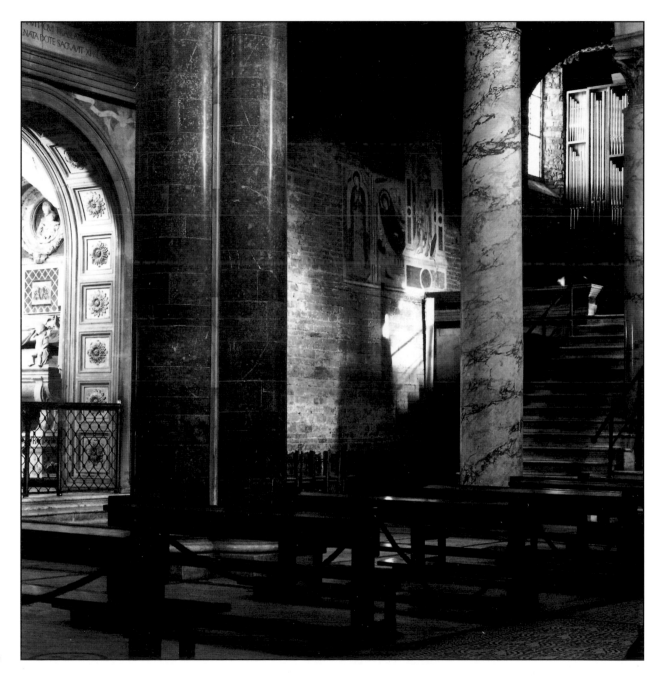

Interior, San Miniata

DIFFICULT MOTIFS

Auto Repair Shop, McClean, Texas

Although national Route 66, America's most famous long-distance highway, officially died in 1976, there is still plenty of life left in what John Steinbeck called the 'Mother Road'. Immortalised in song by Nat King Cole, and a multitude of other renderings of Bobby Troup's catchy *Get your Kicks on Route 66*, 'Historic Route 66' has become big business. There are many sections of this famous commercial route still in use. In New Mexico, for instance, from Grants to Laguna Pueblo there are working remnants of old 66 – though, in places, a little worse for wear. Driving along this section was like having my own private road to zip along, a delightful change from the cut-and-thrust of a 'trucker Grand-Prix' on the Interstate-40.

During one of several nostalgic trips to the West, on a wet and dreary day seventy-five miles east of Amarillo, I turned off the I-40 to look for lunch in McClean, (population 900) Texas. There, where old 66 ran through what seemed like a deserted town, a small family cafe was still doing business. While the owner chatted about past times, he served a simple meal of tacos and guacamole, enough to ward off a nagging hunger. McClean, it seems, had been heavily dependent on a transit trade that faded quickly when the new superhighway bypassed the old town. It's an all-too-familiar story. The result is a different kind of ghost town: urban decay, a polite term for empty building lots, trash heaps and rusting auto wrecks, a wasteland of American dreams.

The dull grey sky added to a depressing sight of decaying buildings and waterlogged alleyways, while an obviously closed hotel – its entrance barred and overgrown with weeds – only seemed to emphasise the feeling of desolation. A nearby auto repair shop had an air of mystery about it too. Through its dusty windows, I could see spare parts and tools lying around as if the mechanics had simply left in the middle of a job, a kind of Easter Island exodus.

Photographing inaccessible motifs through murky windows is just another of the quixotic ideas that come to bait me. To minimise reflections, I adjust the tripod legs so that the camera lens hood (a simple flexible rubber type) is pressed hard against the glass. I measure the available light the same way, holding the meter against the window, shading it with a hand from stray light above.

One can also use an electronic flash through a window, but again, the flash unit must be pressed against the window with the reflected light sensor covered – a fingertip will suffice. I also keep a roll of kitchen paper in the backpack; it comes in handy to wipe windows clean. The other difficult thing about this kind of motif is trying to get the best composition with few, or no options regarding tripod location. They are often 'Hobson's choice' situations; the image has to be made in the only spot available – usually where the motif first caught my eye.

This was not the only time I've wanted – and got – an otherwise inaccessible window image. While roaming around the village of Suvereto in Tuscany, I spotted two classic post-war barbers' chairs through the shop window just as the doors were closing – for lunch as I thought. My only option was to photograph through the none-too-clean glass, using a sunshade and tripod as before. What I didn't know was that the barber had just closed his shop for the last time. Returning a few days later to surprise him with a print, I couldn't believe my eyes; the shop was completely empty. He had moved to new premises a couple of streets away. My simple picture had already become a time capsule.

The result with *Auto Repair Shop* was better than expected, a negative on Ilford Delta 100 with a good tonal range that prints easily. A generally overcast day is no bad thing with black and white photography, and it can make exposure for images like these a lot easier. The range of available light inside the old workshop was just about four f-stops. It was not necessary to aim for a great depth of field; I simply checked the nearest and furthest points of focus to ensure these would both be covered – rather like focusing a large-format camera. The older Hasselblad Zeiss lenses have a neat little window with two red pointers that move to indicate the increasing depth of field with each f-stop down; it certainly saves having to calculate the hyperfocal distance (see p. 44).

Things are not always what they seem. The rain and gloom completely belied the true fate of a town making a concerted effort to recover from the demise of Route 66. McClean's citizens have seized the advantage of being geographically at

USSW 95-4-66/70

Negative Data

Image: Auto Repair Shop
Format: 6 x 6 cm
Camera: Hasselblad 503 Cx
Lens: 1:3.5/60mm Zeiss Distagon
Film: Ilford FP4-Plus
Developer: Ilford Perceptol

Print Data

Enlarger: D2 Aristo cold light
Lens: Rodenstock 105 mm APO
Fine print: Ilford MG IV-FB
Developer: Amaloco 6006 1:7
Toner: Kodak Selenium 1:20
Mounted size: 12 x 13 inches

the centre of the most glamorous of all US highways, promoting their town as 'The heart of old Route 66' and establishing the largest museum of its kind, dedicated to a famous road.

Among various American Heritage presentations, the town is proud of its Devil's Rope Museum, a unique exhibit of artefacts, information and photographs describing the extraordinary history of barbed wire. The impact of this invention on farming and the land in general, the fencing-in of America, makes an interesting story. With the settlement of the great plains and growth of vast herds of cattle, stockmen needed fences to contain the cattle and prevent rustling. At first, field barriers were just large rocks and juniper branches piled together, but these soon proved ineffective against determined cattle thieves. One of the first wires used for fencing was known as Kelley's 'Diamond Point' patented in 1878, followed soon after by literally hundreds of variants. Designs were gradually improved over the next decade or two, mainly to prevent injury to the animals. Barbed wire became known as the 'Devil's Hatband' among cowboys of the time.

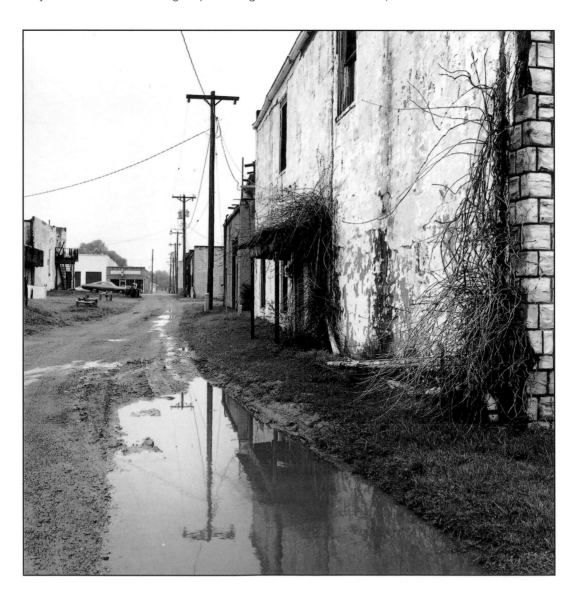

*A rainy day in
McClean, Texas*

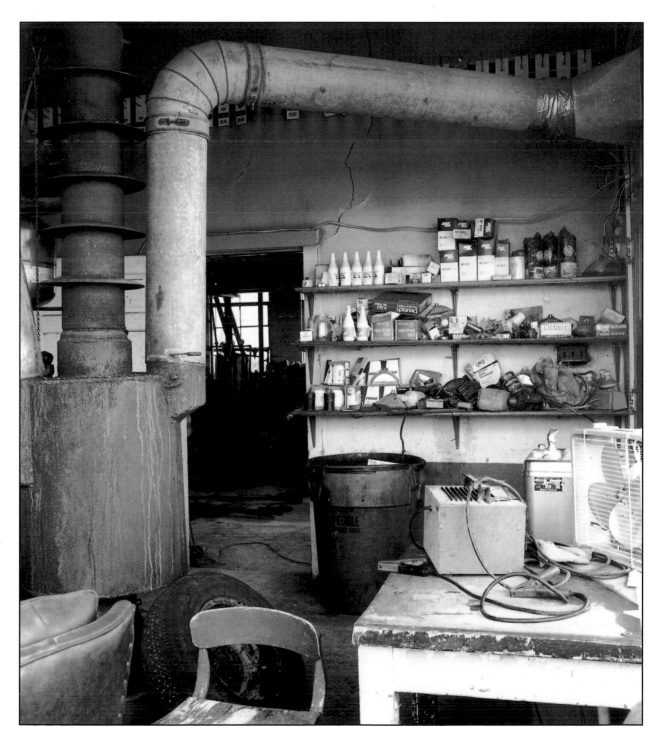

Auto Repair Shop
McClean, Texas

PROBLEMS WITH WINDOWS
Empty Rooms, Empty Chairs

My favourite photographic subjects are empty interiors: a café, a tavern or a church – indeed, any sort of interior that bears the traces of human occupancy or endeavour. I might find this in a seaside espresso bar, devoid of customers in the quiet of winter, or in a deserted railway waiting room where the presence of passing occupants can still be sensed, lingering. They are there to find – for anyone with sensitive-enough antennae. Empty chairs too are just as fascinating; for me they symbolise times past, present and the future. In the leaden, afternoon anticlimax of Christmas Day, the neatly arranged seating of *Café Follonica*, appears to be awaiting expected guests, or perhaps the unexpected ghosts of former patrons seeking their favourite chair. Listen carefully and you might just hear that old Bentwood chair creaking in the gathering gloom of evening.

Sometimes a photograph can be the exact opposite of reality. *Taverna Lesbos*, found during a photo-workshop in the Aegean Islands, is a classic example. The black iron stove, the central feature of the tavern, immediately attracted my attention. It was easy to imagine the local folks standing around it in the winter, exchanging village gossip spiced with coffee and ouzo. The place appears empty, closed for the afternoon or maybe at a season's end. Actually, behind me were bewildered tavern owners surrounded by a dozen hungry workshop participants. They had been photographing late into the afternoon and were now loudly discussing the menu for a belated lunch. None of them were the slightest bit interested in what I was doing. On the right-hand edge of this picture, now cropped out of sight, a local villager struggles to finish his bread and soup in peace before that noisy bunch of intruders take the place over. Who said a camera never lies?

The problem with both of these images was a long window area that raised the contrast range – so high that a compromise exposure was needed to get a useable negative. In both cases the top end of the range fell on zone IX, even when the black chairs or the old stove were placed just above the film's threshold of sensitivity. However, if most of the film is already exposed on normal contrast motifs, it is a no-win situation for roll-film users; the proverbial fly in the ointment. Despite all claims, the Zone System only really works with separately exposed and developed sheet films.

Contact printing (note black card for balancing exposures).

With twelve images on a normal 120 film there is little else a medium-format user can do – except cut the film into smaller pieces for their respective N- or N+ developments, but this is taking things too far in my opinion. Of course, one could use several film magazines, each one loaded with the same kind of film, rather like a large-format camera user with separate sheet film cassettes – I aim to *enjoy* my photography, not be a slave to it!

As usual, these images came at me 'out of the blue' leaving little time for finesse. In cases like these, I tend to shoot from the hip and correct the near misses at home. Purists might sniff at this, but at least I get images this way,

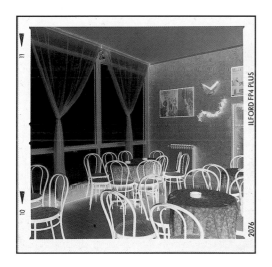

Negative Data
Image: Café, Follonica, Tuscany
Format: 6 x 6 cm
Camera: Hasselblad 503 Cx
Lens: 1:3.5/60mm Zeiss Distagon
Film: Ilford FP4-Plus
Developer: Ilford Perceptol

Print Data
Enlarger: D2 Aristo cold light
Lens: Rodenstock 105 mm APO
Fine print: Ilford MG IV-FB
Developer: Amaloco 6006 1:7
Toner: Kodak Selenium 1:20
Mounted size: 11½ x 12 inches

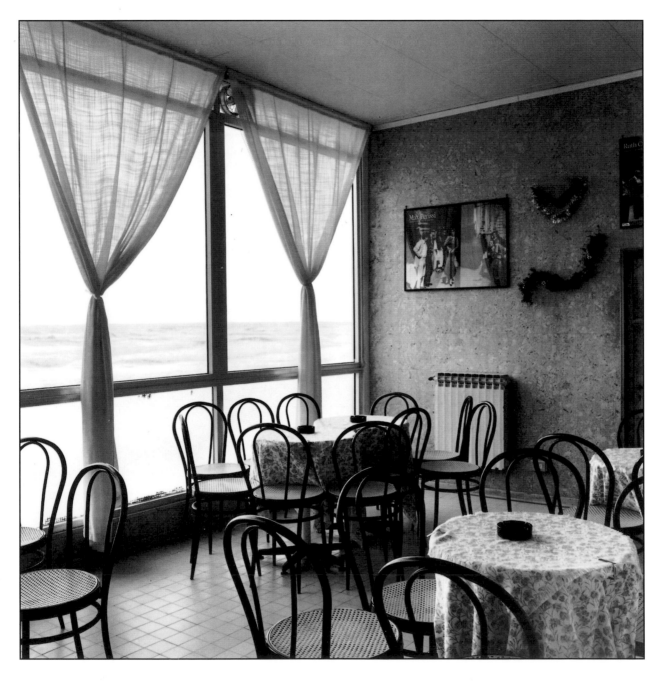

Café, Follonica, Tuscany

however difficult they may be to print. All is not lost, however, even in really bad cases of overexposure or over-development. With *very* careful treatment in Farmer's reducer, the developed silver density can easily be cut back to a more printable level. With practice, one can arrive at a rough scale: 'two minutes equals one f-stop reduced', but this depends on the dilution strength. Try it out on some old negatives first, before taking any irrevocable steps. Underexposure is a far greater problem. If there is *no* developed silver, all is indeed lost!

Readers may have noted the frequent mention of contact images or sets. They are the main key to one's photo-archive, and the first step in a lengthy sequence leading to the fine print. Ideally, each contact sheet should show all the images on a single roll of film and be suitably annotated with some kind of meaningful code (if only to yourself) in a data retrieval system. Secondly, it should enable a quick assessment of each image to see if it is worth going to the next stage – the so-called 'work print'.

Contact sets are best printed on a glossy paper, for example Ilford MG IV RC, with a #1 filter. A soft grade helps to show what the negatives really have to offer when viewed through a magnifying glass; to be quite sure of details or sharpness, put the contact print on a light box to shine through the RC paper. Placing separate strips of film on the paper in semi-darkness is too time-consuming, especially when sometimes there are fifty or more sheets to contact print. Instead, I use a 10 x 8 Paterson contact printer, exposing the paper through the polyethylene negative preservers made by 'Print File' in Florida. All my films are stored in this archive quality material; it is chemically inert and absolutely safe for long-term storage.

Other suppliers in America use Mylar, an equally inert plastic used in the aerospace industry. Secol Limited of Thetford, UK, manufactures film sleeves in Polyester, a totally safe material approved by several national museums and archives. If you treasure your work, avoid film storage sheets made with PVC; this can give off some pretty nasty gasses – but slowly.

Making contact sheets can also be an art. When one or more of the negatives shows a marked under-exposure, I cover it with a strip of black card (Ilfochrome packing), placed on the glass contact printing frame (see illustration, p. 84). If the nominal printing time is, say, twelve seconds for the remainder of the images, but only four seconds for the thin negative(s), the timer is set to four seconds and the main group of images given two bursts of exposure. The covering strip is then removed for a further four seconds to complete the exposure. This procedure can be also used in reverse to re-expose parts of the print under a particularly dense negative – yet another Todd fudge, but with practice it produces contact sets that look like masterpieces. In an ideal world, where all images are perfectly exposed and developed, one could use a standard enlarger height/exposure time for maximum black in a print. This is found by making a test strip from a piece of unexposed but *developed* film base, i.e. 'f + fb', set in the negative stage half-way so that the full unobstructed enlarger light exposes one half of the paper. The strip and exposure time giving maximum black *through the film* can be defined as

Heiland TRDZ Densitometer

'standard printing time', relevant of course only to those enlarger settings and paper format.

Having selected the most promising image(s), the next step is making a full negative format on a 10 x 8 inch RC print. This is when the main assessment begins; when decisions are made on what to crop, where to dodge and burn. The result of this analysis is called the 'work print', forerunner to a 'proof print' and a 'fine print' on fibre base paper – more about this in Chapter 18. There are thus four stages in the work plan *before* I commit an expensive sheet of paper to the enlarger's lamp.

The choice of paper can be difficult sometimes. While favouring Ilford papers for most of my work, I occasionally use other marques such as Agfa, Forte, Oriental and Maco for different tonal renditions, or unusual surfaces – as is possible with Kentmere Art Classic for instance. In general, I find that a landscape looks better with a slightly warmer tone, but for a still life or a graphic image, colder tones are more preferable. This is very much a personal thing and one cannot, or should not, be dogmatic about it.

DEVELOPING TIPS

• Use adequate amounts of fresh developer: at least two litres for a 10 x 8 print in an 11 x 14 inch tray, three litres in a 16 x 20 tray. The same goes for stop and fixer baths.

• Maintain developer temperature at 20° C with a tray warmer. A domestic plate warmer will do just as well, and is usually cheaper. A sheet of aluminium, 1/8 inch thick and big enough to support a 16 x 20 tray will spread the warmth and prevent hot spots. Keep the fixer bath warm too, if possible.

• If the image doesn't appear within twenty seconds (forty seconds on an FB print) the exposure is inadequate, or the developer could be stale – or too cold (<16˚ C). When the image appears almost instantly, you forgot to stop down again after rechecking the focus; it does happen – often!

• Continually rotating a print, alternately face up, then face down, will give a slight increase in contrast.

• The manufacturer's times for developing papers should be accepted and used; they know best. When a print is properly exposed it will fully develop within the prescribed time, usually two minutes for RC papers or up to four minutes for some FB versions. Using a stop bath to cut short development is not acceptable. Leaving a print in the developer well beyond the recommended time will not deepen the blacks any more (see graph below).

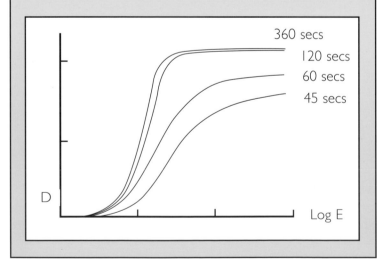

Still more development tips.
Bubbles can and do occur.

I made a mistake with this contact print, but instead of just tearing it up, I threw it in the developer and got on with making another print. Without immediate agitation an air bubble formed.

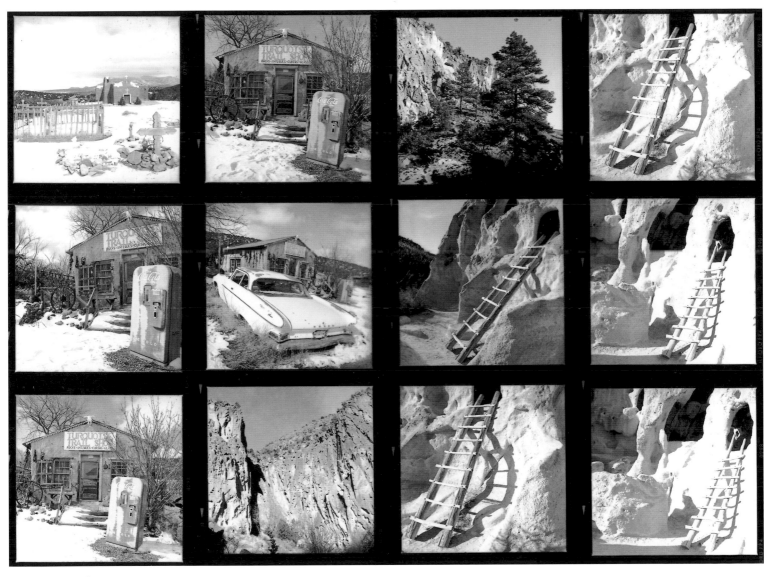

Contact sheet; New Mexico, 91/01-66-08.
Contact prints are the key to one's archive.

Negative Data
Image: Café, Lesbos, Greece
Format: 6 x 6 cm
Camera: Hasselblad 500 CM
Lens: 1:3.5/60mm Zeiss Distagon
Film: Ilford FP4
Developer: Ilford Perceptol

Print Data
Enlarger: D2 Aristo cold light
Lens: Rodenstock 105 mm APO
Fine print: Ilford MG IV-FB
Developer: Amaloco 6006 1:7
Toner: Kodak Selenium 1:20
Mounted size: 12½ x 14½ inches

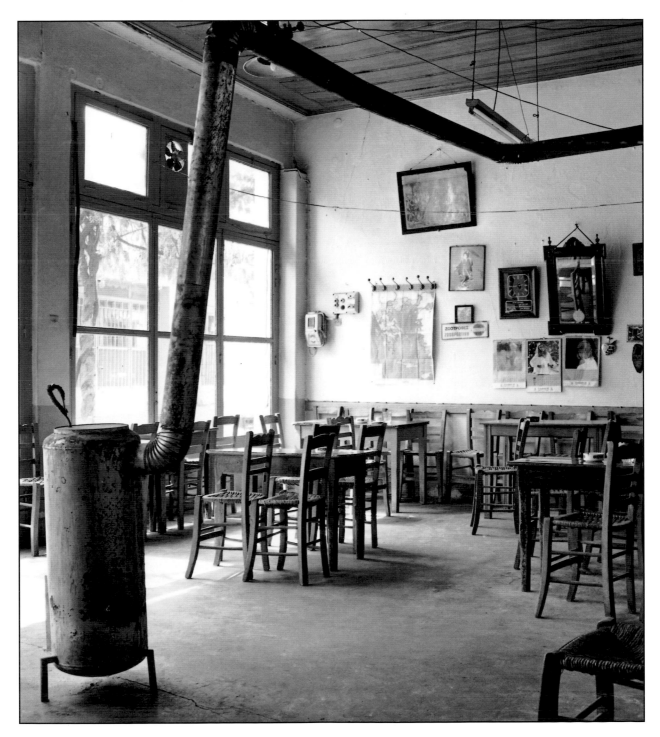

Taverna
Lesbos, Greece

PROBLEMS WITH WINDOWS

DIFFICULT NEGATIVES

Olive Grove at Vetulonia, Tuscany

Winter sunshine was slanting through a grove of ancient olive trees, a classic image such as I had always hoped to find in Greece, Spain or Italy. My search was over at Vetulonia in Tuscany where 2500 years ago the Etruscans built several tombs. There, the rich and famous of the day were buried in sculpted chambered tombs with fine gold and other worldly goods – treasures laid bare by mid-19th century archaeologists. Unfortunately the historic site was closed until Easter, but as I turned away disappointed, this magnificent group of gnarled olive trees caught my attention. For this old 20th century photographer it was a gift; it also presented a special challenge: how to look almost directly into the morning sun without a lens shade. This was lying in its box, safely stored at home. Never one for giving up easily, I tried several shots with my hand hovering over the lens, hoping to hold that position while tripping the mirror for a vibration-free exposure.

On developing the film, it was clear that my goal had not been achieved; there was a large shadow across the top left-hand corner of two images. They were negatives that others might well have thrown away. But sometimes it pays to keep such failures. I used one of these in an article about Tuscany published in Hasselblad *Forum* 4/96, with the shadow cropped out and the resulting square format image printed reversed to give a better flow. The two versions are shown here, so that readers can judge for themselves which is better: the original or the other way round. The latter uses a well-tried composition device; a long shadow, running towards the base of the nearest tree, helps direct a viewer's eyes from the ·lower left to the upper right-hand corner of the picture. Indeed, there are several pictures within this one negative, which was very nearly a washout!

Besides the hand-shadow problem, *Olive Grove, Vetulonia* turned out to be a less than perfect negative, partly because I set the exposure values too low for the deep shade under the trees. This let the sunlit grass values fall between zones V and VI; a stop higher would have been better. Longer development (about 25%) would have brought the shadows up a stop or more, but this would also have increased the highlight densities. In an ideal negative, a subject contrast range of

Dodgers and an adjustable burning-in card.

five f-stops should produce a density of 1.25 above base fog (f+fb).

Olive Grove has a D max of 1.45 above f+fb however, while the still useful majority part (under the hand shadow) registers a mere D = 0.80 above base. The problem with a thin negative like this is that areas of dense silver – namely the highlights – tend to block up quickly when printing via a hard grade filter, especially in condenser enlargers. (see Callier Effect, p. 93).

Two valuable darkroom tools and techniques can help solve this difficulty. The first is to use a diffuser, or better still, a cold cathode light source. Reams have

THE CALLIER EFFECT

Named after the Belgian amateur physicist André Callier (1837-1938), who noted that direct or specular light (i.e. via a condenser) produces greater contrast than indirect light rays. On striking denser parts of a negative, the direct light rays are scattered or reflected back towards the light source. Fewer rays will penetrate the higher densities to the paper, causing weaker print values in the higher ranges, 5 to 8. Print tones below the mid-range (tones 2 to 5) are not significantly affected. This can be offset by adjusting the exposure index and development times to give a lower contrast index (CI) or gamma specifically for condenser enlargers. A diffused light source, however, can be regarded as random; proportionately equal amounts of light pass through the negative, enabling prints much closer to the negative values. A negative density measured by diffused light will have a higher density in direct (specular) light; the ratio of these two densities is known as the Callier Quotient or Q factor.

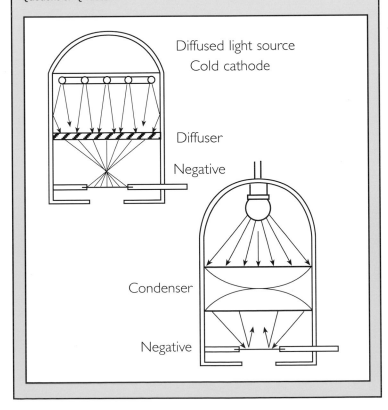

Diffused light source
Cold cathode

Diffuser

Negative

Condenser

Negative

been written and argued about the relative worth of condenser v diffused or cold light, but when I switched from a condenser enlarger to a diffused light source in an LPL 4551 enlarger, the quality of my black and white printing improved noticeably. It made a quantum jump after fitting an Aristo cold light unit to my antique Omega D2. Don't believe the detractor's stories about diffused v condenser light; my prints are just as sharp using a diffused light source. Admittedly, Rodenstock's latest Apo lenses probably help too. The other way to ease the contrast problem is to use a combination of hard and soft grade filters – the split-grade method of printing (see chapter 17).

The sequence of pictures on page 98 compares the uncropped image with a series of work prints, showing the expansion or compression of tones possible with variable contrast papers. The best tonal separation on *Olive Grove* was obtained with a grade 4½ filter on Ilford Multigrade IV-FB, plus some lengthy burns with a soft filter for those heavily blocked highlights. It is amazing what a touch of grade 0 or 00 will do on a difficult negative like this one. Be careful though: there's a world of difference between a brilliant zone VIII, with faint traces of texture, and a dull chalky tone pretending to be white.

The inability to get white tones, clearly distinguishable from paper white, is another problem area in black and white printing. Muddy highlights are often blamed on lens flare, or light escaping from around the negative stage (a common fault) while reflections from a white ceiling above the enlarger are a generally unsuspected cause. Ideally the ceiling should be painted black to prevent reflections. My darkroom ceiling has dark simulated wood insulation panels – but a large piece of black card would do just as well. If there is enough space, black panels on either side of the enlarger to form a cubicle will help to reduce stray light from a so-called darkroom 'safe light'. This may not be quite so harmless if it is not well away from the enlarging easel or chemical trays.

The safe light (Ilford DL10, 902 filter and 15 watt lamp) in my darkroom is mounted nine feet away opposite the work space, high up on the wall and tilted toward the ceiling. And yet, being ultra-cautious, I always slide exposed paper face down into the developer and immediately turn it over once to make sure there are no trapped air bubbles, then turn it face down again. I leave it like this while rocking the tray – only turning the print over when the developing process is almost over. Remember that when paper has been exposed, it has been raised above its sensitivity threshold.

If you are limited to a very small darkroom, it might pay to check just how 'safe' this light is. First, it is necessary to determine the minimum exposure required to produce the first visible grey tone on a grade 2 paper, or any variable contrast type *without* a filter. When dry, the result should equate to exposure through a zone VIII negative (density ca 1.35 above f+fb.) Then, cut a quadrant out of a piece of thick card (see sketch) and place this over a 10 x 8 inch sheet of photo-paper *pre-exposed to zone VIII*. Set a lens cap or a coin in the middle of the open quadrant and make the exposure sequence shown on p. 97. The coin should not leave a photogram.

STEPS IN THE DARK ...

Step 1. *Always* close the box or packet before exposing a sheet of paper under the enlarger. Careless work costs paper (sound familiar?).

Step 2. *Take* your time - no need to hurry. It's all too easy to upset something in the dark.

Step 3. *Check* again that the paper box is still closed before turning the darkroom lights on. Double check; it avoids spoilt paper - at best just a few sheets.

Step 4. *When* steps 1 to 3 are not enough, invest in a 'Paper Safe'.

PRINTING TIPS 1

Once there were only paper grade descriptions like 'soft', 'medium' or 'hard' to guide the printer. Variable contrast papers changed all that.

Now, with a density reading analyser, you can easily determine the best matching grade for any negative by using the paper manufacturers designation: R, meaning nominal contrast Range. This is an ISO defined value, where the normal unfiltered grade (2) is R 100.

For example, if a negative has an effective density range of 1.2, this figure, multiplied by 100, will give the ISO range figure as seen below. Thus, the full print range will be given with a grade 1½ contrast filter.

Filter:	00	0	1	2	3	4	5
Range (R) :	180	160	130	110	90	60	40

Richard Ross' 'Analyser Pro'
A great darkroom tool, for giving the perfect print (see p. 105)

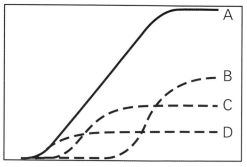

Exposure to green light

A. combined curve
B. dyed emulsion 1
C. dyed emulsion 11
D. dyed emulsion 111

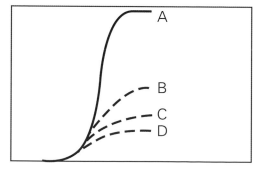

Exposure to blue light

A. combined curve
B. dyed emulsion 1
C. dyed emulsion 11
D. dyed emulsion 111

Working with variable contrast papers

Another piece of darkroom equipment that might need some fine-tuning is the enlarging easel, more specifically its top surface. For years I used a Pelling and Cross (Durst) easel covered with a thin sheet of black paper to stop possible print-through on thin RC papers, though I have still not confirmed to my own satisfaction if this really happens in every case. I do know that when a sheet of RC paper is placed the wrong way up on a *white* easel and exposed to a normal density range negative for, say, ten to fifteen seconds, a fuzzy image will develop; on a black easel there is no effect. The jury is still out on this subject.

So far as I know, Dunco of Berlin is the only European manufacturer making an enlarging easel with a middle-grey surface; matt black would be even better in my opinion. Kostiner's easels are black overall. Some easel suppliers say their customers prefer a white surface, as it makes setting-up easier. Nonsense, why not set up and focus on the back of an old print? However, while some believe it is better to focus this way the true plane of sharpness (accurately focused) does not differ more than a few microns, with or without a piece of paper. It lies well within the thickness of photo-sensitive emulsion.

I pride myself in still being able to file a pretty square edge, a skill that I've exercised on all my enlarger negative carriers of my Omega, and LPL enlargers.

The designers seem to have forgotten, or ignored the fact that light (except under gravitational force in deep space) cannot bend round a corner, or in this case, past a square edge. To obviate light fall-off due to this effect, the upper halves of all my negative carriers now have a 45° chamfer. Moreover, I had to file them out in order to see the *whole* image. But it is not only on metal carriers that you find this problem; there are many examples of it in plastic carriers, where the manufacturer missed the opportunity to include it in the mould design – or simply didn't consider a chamfer necessary.

Finally, I believe that all darkroom work should be recorded, even when repetitive – if only to keep a note of the printing done in the past week, month or year. I note every contact set, enlargement (see p. 96) or experiment, whether on paper or film. The file number on this example indicates an average of one entry (the number of prints might be more) per day over the past ten years – not bad considering the several long periods for which I was away from base. Many of the prints made for this book are noted in the relevant columns. It is not necessarily a perfect formula, and other darkroom workers have surely got their own, perhaps better, ideas about documenting work. Nevertheless, please feel free to copy this form.

Darkroom Log														Sheet #	
Image			Paper				Enlarged		Exposed d		Filtered			Notes	
Date	Film	Archive #; Title	BW	y	m	c	h. cm	lens	f	t	y	m	c	Grad	

Darkroom log

Date	Film	Archive #;Title	BW	y	m	c	Enlarged h. cm	lens	f	t	y	m	c	Grad	Notes
22/9/99	Delta 100 6x6	3-98/579 Signal Box	MGIV 20x25				39¾	105	5.6/8	13				2½	+5 sec sky Gr 5 +5 sec LH (Landscape) Gr 3
23/9	HP5 6x6	3-90/121 Sepp the Bellringer	"				43	"	8	7				2½	Straight (very slight dodge fgnd) Cropped to 14 x 21.
"	FP4 6x6	3-90/64 Kreitkeyer & Son	"				42	"	8	6				2½	+ 2 sec. Grade ∅
"	FP4+ 6x6	3-93/387 Heiko	"				42	"	5.6	10				2½	+ 3 sec. Grade ∅
24/9/99	FP4+ 6x6	3-96/562 Variegated Lady	"	(cropped)			40	"	8	10½				2½	+ 2 sec. Grade ∅ Statue HL's + 3 sec. " " Sky
"	FP4+ 6x6	3-96/567 San Miniata	"				33½	"	11	5.3				5 !	+ 2 sec. Grade ∅ LH H'Light.
"	"	3-95/446 Las Trampas	"				33	"	8	8½				2	dodge RH pew & icon ca 2 sec + 2 sec Gr ∅ rear wall.
26/9/99	"	3-95/458 Auto Repair Shop	"				38	"	5.6	16				2½	dodge doorway (centre) + 4 sec. Gr ∅ RH side
"	"	3-95/557 Cafe Follonica	"				33½	"	8	8				2½	+ 1 t burn, window Gr ∅ dodged tables + wall ½ t.
"	"	3-96/246 Taverna Chios	"	(cropped)			38½	"	8	8½				2½	dodged RH chairs thro' to centre 2 sec burn LH; 1 t Gr ∅ window
"	"	3-96/549 Olive Grove	"		"		42½	"	8	10				4½	dodged upper ½ trees, ½ t, + 2 t burns Gr ∅ grass HL's
"	Delta 100 6x6	3-98/599 Hotel 1st Floor	"				33¾	"	11	5				5	+ 2 sec LH (column/wall) Gr 2 + 2 t burn Gr ∅ window.
"	TMX 6x6	3-92/206 Peppers Cove	"				53	"	5.6	16				2½	slight dodge of deepest shadow
"	Pola 55P/N	3-91/281 White Sands Dune	"				43½	150	8	4				2½	+ 1½ sec cruise brown sky Gr.5
"	TMX 6x6	3-93/328 Bedroom, Fantasy	"				38¾	105	8	7				2½	dodge bedhead 2 sec + 2 t Gr ∅ bedcover H.L's.

Darkroom log

TESTING SAFE LIGHTS

Establish minimum exposure for first visible grey tone on grade 2 paper (or Multigrade, MCC or VC types but without contrast filter). In total darkness, pre-expose one 10 x 8 inch sheet to this minimum exposure and place in easel with test 'L' and a circular object, e.g. a coin. Switch on safe light and rotate test card at intervals as shown. Develop print immediately. It should show no trace of a circle.

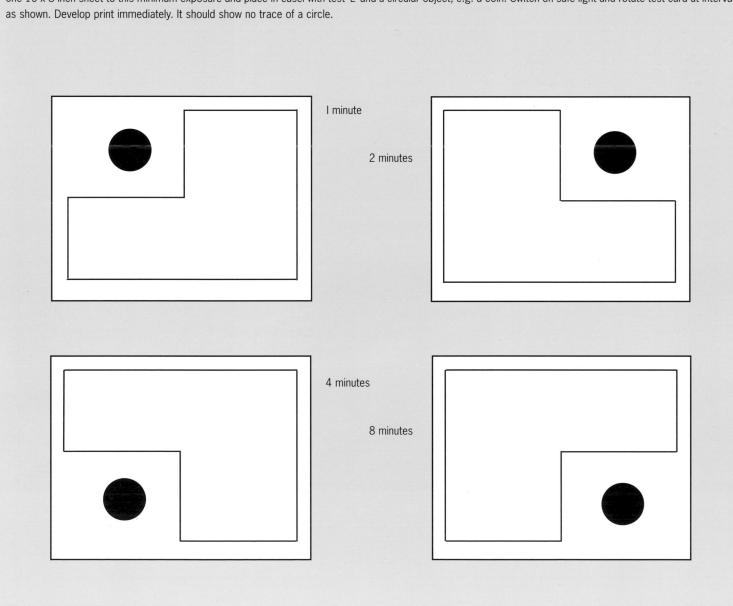

I minute

2 minutes

4 minutes

8 minutes

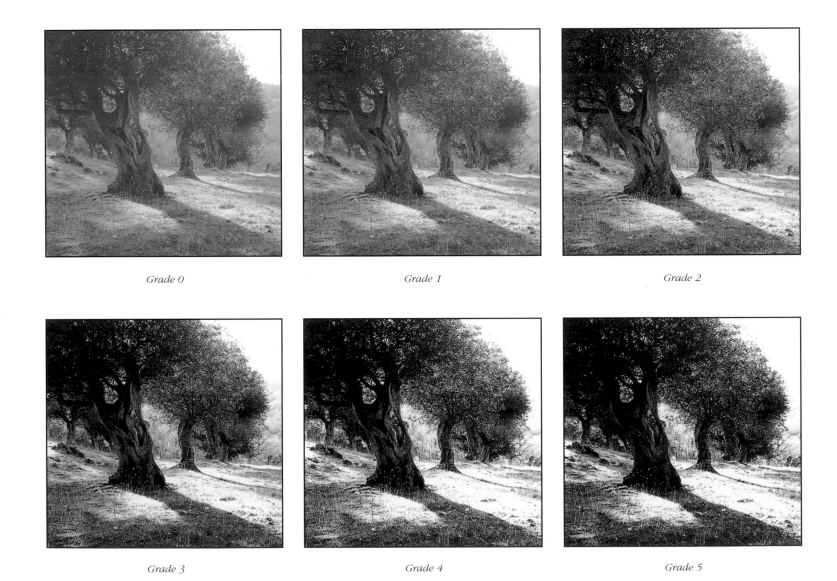

Grade 0

Grade 1

Grade 2

Grade 3

Grade 4

Grade 5

Contrast according to the grade selected

Negative Data
Image: *Olive Grove, Vetulonia*
Format: *6 x 6 cm*
Camera: *Hasselblad 500 CM*
Lens: *1:3.5/60mm Zeiss Distagon*
Film: *Ilford FP4-Plus*
Developer: *Ilford Perceptol*

Print Data
Enlarger: *D2 Aristo cold light*
Lens: *Rodenstock 105 mm APO*
Fine print: *Ilford MG IV-FB*
Developer: *Amaloco 6006 1:7*
Toner: *Kodak Selenium 1:20*
Mounted size: *14 x 14 inches*

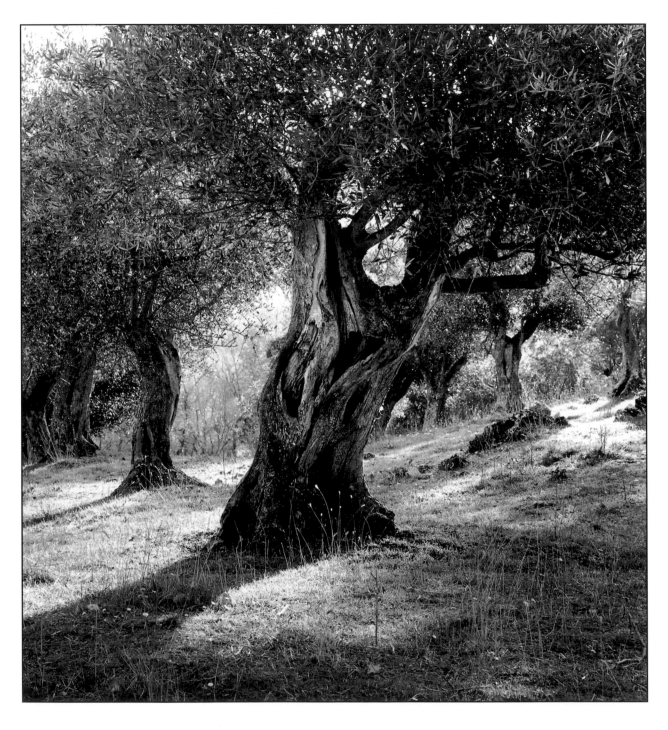

Olive Grove, Vetulonia

CHAPTER SIXTEEN

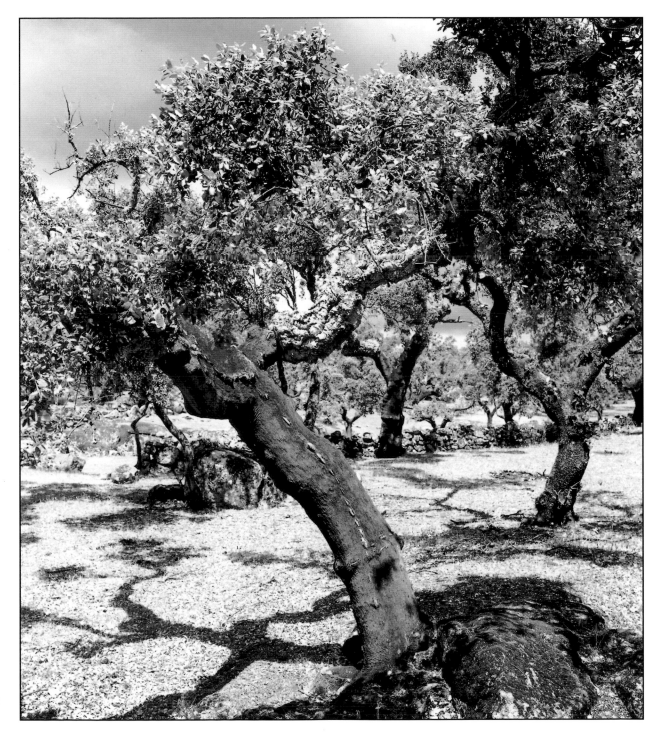

*Cork Oaks,
Portugal*

DIFFICULT NEGATIVES

PRINTING ON VARIABLE CONTRAST PAPER

Hotel 1st Floor

Well really, there are *far* more beautiful things to photograph in Portugal than *that*' the innkeeper said, clearly upset at my strange choice of motif. 'That' was an untidy heap of timetables scattered over grass-covered rails at the defunct railway station opposite his place. 'But if you really *must* photograph that kind of stuff' he continued, 'there's an old hotel in ruins, just across the way'.

I had chosen to stay overnight in a sleepy *fin de siècle* Spa that had perhaps seen better days. Before the railway closed, the healing waters used to bring enough visitors to more than fill the town's two quite palatial hotels. Now, there is only one. It seems there had recently been a fire, though it hadn't actually gutted the second hotel. I wanted to find it immediately, but the sun had begun to dip behind the hills, so my search for exciting new images had to wait until morning.

The hotel – there must have been up to a hundred rooms – was still in surprisingly good condition considering it was not fenced off. A pool in the rear courtyard, surrounded by a much overgrown sunken garden, must have been a delightful place on those long-ago evenings to sip a cool *vinho verde* to the sound of a melancholy fado. I couldn't believe my luck at the main entrance; its *art nouveau* doors were open, a clear invitation for inquisitive people like me. On entering warily, the wide curving staircase, surely a central feature of the entrance décor, triggered all kinds of images. Ghosts of yesteryear were close at hand. One could imagine the rustle of evening gowns as elegant ladies daintily stepped down the stairway to join the other diners. Now the mosaic-tiled stairs were littered with bits of burnt plaster and ceiling lath. (See p. 49.)

As my eyes became more accustomed to the gloom, it was clear that any film exposures would go well beyond the limits of reciprocity. But there was no option; my usual fumble factors would have to be applied. After a few shots of the foyer, I decided to venture up those tempting stairs with Hasselblad and tripod. Part of the first floor was burnt through in places, but after crossing like some high wire artist on an I section girder to the upstairs hallway, this evocative motif halted any further investigations.

Far more beautiful things ...

Components:
1. Halogen lamp
2. Infrared filter
3. Diffuser box
4. Filterwheel
8. Motor
9. Controller
10. Transformer
11. Probe for high measurement

Schematic of a complete Splitgrade system

The viewfinder showed a worthy addition to my collection of nostalgic ruins, and needed little effort to find the right composition. Then I remembered that the spotmeter was down below at the entrance; to fetch it meant another trip across that open beam! On returning with the meter, I saw there was only one exposure left in the magazine and the spare was in the camera bag – below stairs. It was all too much. In truth, I was scared the burnt and rotten floors might give way at any moment. Now of course, I curse my faint-heartedness and reluctance to snoop around the place a bit more.

This is a difficult image to print because of its long density range, from <0.1 to a max D of ca 1.7, about nine f-stops; that over-exposed window at the end of the hallway adding the extra two or three stops. I had little choice really, though a powerful flash directed into the dark corners and remains of the ceiling might have helped to raise the shadow values a stop or two. In another situation, I might have considered stopping down still further to use a long time exposure and 'light painting' – several consecutive doses of flash, though you have to watch out for tell-tale shadows.

Despite its apparent long range, there is not a lot of silver density in this image, being mostly shadow with a concentrated highlight in the window. The result was another demanding negative to deal with, the kind of problem that variable contrast papers can solve by making multiple exposures with different filters. Variable

The Wilhelm Heiland Wonder Machine (control box only).

PRINTING TIPS

Keep the exposure time short; between ten and twenty seconds is ideal, and allows time for dodging. Don't stop down too much; one or two f-stops is enough, and usually near the optimum aperture for best performance. If the enlarger lamp is too bright, use a neutral density filter to reduce the intensity by a known amount, e.g. ND1, D = 0.3 or 1 f-stop. The filter could be placed inside the lamp-housing, on top of the lens.

If you use an enlarging analyser or comparator, check the evenness of light-coverage on the print easel. Almost certainly there will be a measurable fall-off towards the outer edge of the projected image. Most enlarging lenses show this tendancy, causing light-loss up to ½ f-stop or more.

Use the appropriate focal length for the format, i.e. 50 mm for 35 mm negatives, 80 mm for a 6 x 6 or 6 x 7 cm format. Better quality, more expensive 'Apo' lenses will improve uniformity. The term Apo generally indicates a six-element apochromatic corrrected lens.

A bad case of fall-off in a 'taking' lens will result in under-exposure (as vignetting) in the corners of a negative (black and white or colour). Assuming a perfect enlarger lens, such a negative would print darker in the corners. This would be compensated to some degree by enlarger lens fall-off.

In positive to positive printing, however, the problem is compounded when both the camera and the enlarging lens are of poor quality. A centre-graded neutral density filter under the enlarger lens will help to correct this problem.

contrast papers use a blend of emulsions that are basically blue sensitive (see p. 107 and 108). By adding different amounts of a green sensitising dye, parts of the emulsion are made sensitive mainly to blue light, parts of it more to green light and other parts of both blue and green light. Various degrees of contrast can be obtained by filtering the enlarger light through the complementary colours (yellow and magenta filters).

Most major photo-paper manufacturers make special filter sets for use with their variable contrast materials. These filters are generally designed to fit into a drawer in the enlarger or, as with the Ilford product, in a holder mounted under the enlarger lens. While some may not like the idea of introducing a filter into the focused light path, there is no loss of sharpness – assuming the filter is scratch-free and clean. After stopping down one or two steps, but seldom more, I always do the final focus adjustments on a spot away from the centre of the image and

with the filter in place (see Ctein's research on image shift).

The dye on contrast control filters (generally a polyester base) can fade with the passage of time depending on the use or abuse they get, so it is probably a wise move to renew filters at intervals after two or three years of regular use. Deterioration in variable contrast filters could be monitored by making a master testprint, recording its densities before storing the print in a cool, dry place for comparison later with another test print. But all this sounds more like the work of a standards laboratory than a home darkroom.

To make an exhibition print of *Hotel 1st Floor*, I established the main exposure first, which turned out to be grade 4 ½ on Ilford Multigrade IV-FB for a crisp print, plus a touch of grade 2 to work a small wonder on the burnt plaster. That over-exposed hall window needed some long burns with Ilford's '00' filter – a real boon on images like these.

True split-grade printing, however, is based on using just two filters: numbers 5 and 0, designed to expose the hard and soft contrast layers of the emulsion shown on p. 94. Thus for any given negative density, a split-grade exposure time is shared between the layers in relation to the contrast desired – for instance, 16 seconds at grade 5 followed by 10 seconds under a grade 0 filter. Remember, however, than *n* seconds at grade 5 are the equivalent of less than half that time in the 'normal' 0 to 3 ½ contrast filter range.

Apart from the need to check contrast, the 'dry-down effect' is important too. A print always appears *darker when dry* than it does in the wet stages due to the reflectivity of developed silver in swollen, wet gelatine. To achieve the desired dry densities, it is generally necessary to reduce the exposure time by as much as 8 to 10%, depending on the make of FB paper; RC prints also darken perceptibly. The RH Designs Analyser (see p. 94) takes this into account, showing a negative's density range against a dry grey scale.

Naturally, printing from a difficult negative like this needs a lot of testing and patience. I used over a dozen 6 inch wide test strips, each one dried for 1 ½ minutes in a microwave while preparing to make a large exhibition print of *Hotel 1st Floor*. A hair drier's warm air wafted over the print will do just as well as a microwave. But never skimp on test strips, in size or quantity; in the end you pay for haste with waste. Of course, if you are in the "Big Spender" league, use a whole 20 x 16 inch sheet, as Ansel Adams did in his video on printing methods. He is seen tearing a large print of a famous image in half for a microwave dry-down test.

Split-grade printing in extreme cases like these has been greatly simplified by an electronic device now available for a range of different enlargers, from 35mm to large format. Developed by Wilhelm Heiland in Wetzlar (home of Leica) Germany, this unique system 'Splitgrade' enables the user to produce a good print *in one shot* from any negative almost irrespective of its density range. My immediate reaction to trying 'Splitgrade' was to remark: 'the best thing since zip-fasteners!'.

It works almost the same way (as I did manually for *Hotel 1st Floor*) by exposing the paper to filtered light selectively; first the hard grade, followed by the softer grades – though there seems to be no difference in print values either way round. Splitgrade analyses the negative, selects an appropriate combination of filters and time to expose the variable contrast layers of the paper sequentially, via a built-in shutter mechanism. This auxiliary shutter feature ensures that the lamp reaches its peak brightness before the exposure sequence begins, controlling the light output to a classic square-wave function so that the typical rise-time and afterglow of tungsten or halogen lamp is completely eliminated.

In practice, Splitgrade decided this negative needed a very soft grade (0) which is not surprising considering it's long density range. By ignoring the window area's peak values, I could set the time and grade to suit a density range of about 0.8, which called for the very hard grade this image needed. I settled for grade 4.8 and some slick dodging – a brief handwave over the deepest shadows.

The ability to use 1/10th grades, and similar f-stop or time intervals, makes

MORE PRINTING TIPS

With the optimum print time and contrast grade along with any interpretative burning and dodging firmly established, it pays to make several practice or "dummy" runs under safelight conditions – especially when using the split-grade method.

Complicated split-grade exposures are best done in distinct steps. For example, if the main print time is 18 seconds, divide this into two parts defined as **t**. The main print time is then 2 **t**; further burns, say with grade 5, are made for 1 **t**, and with grade 0 maybe only ½ **t**. To ensure a smooth process in the semi-dark, lay the filters out in the order of use. Don't forget to place the main print filter back under the lens (or filter drawer) ready for the next print. Note the procedure in the log book (or on the test strip if retained) so that it is easier to repeat.

Lastly, for a quick check of print dry-down, put the already dried "final" test strip back in the fixer beside a repeat test for comparison under normal lighting. They should look identical. Note how the higher values (faint texture in white clouds visible on a dry test print) now appear to be underexposed when wet. The difference in exposure can be 8 % or more.

Heiland's 'Splitgrade' ideal for fine tuning image contrast. I believe that with normal, uncomplicated negatives, one could easily dispense with time-consuming test strips for run-of-the-mill jobs.

To burn-in difficult areas like that hall-window, I used a piece of black card about 24 x 24 inch square, with a thumb-sized hole in the centre of a white area, as shown. For the print shown here, a smaller card with a window-shaped cut-out was placed in the centre recess. I have a number of drop-in cards like this one. Before starting a burn, I cover the hole with a finger, then quickly locate the area when the light comes on and uncover the hole – looking at the white card, *not* the paper beneath. For really difficult burns, I open up the lens a stop or more. The Analyser's clever 'Busy' function allows me time to position dodging or burning tools over the easel.

In retrospect, the job might have been easier with the classic plastic cup flashing trick as Phil Davis describes in *Beyond the Zone System*. Coupled with a careful choice of paper grades, pre-flashing is a worthy contrast control tool and should not be sniffed at, as some purists probably do. Try the plastic cup method – it really works and is a simple way of reducing contrast. But determine the time needed first, by exposing a few test strips. With a negative in place and focused, hold the open end of a cup over the enlarger lens, set the aperture a couple of

ARTFUL DODGING - OR THE BURNING QUESTION

• Dodging is legitimate, but its effects should not be readily visible to anyone else but the printer/photographer; only he or she should know where and how it was done.

• Dodgers can be any shape to suit a variety of problems. They can be made of card or plastic, matt-black painted and attached by epoxy resin to a 12 inch length of thin flexible wire (e.g. 24 gauge piano wire).

• Keep it moving; the slightest pause while dodging will reveal your diabolic tricks! Hold a dodger steady for just one second above a print; you will soon see it how it leaves a 'shadow' (white in a monochrome print.)

• Exercise your plan of action: make timed dummy runs on test strips to see which part needs more work than others. The same applies to burning-in.

• To burn or not to burn – it depends what's at stake (your reputation if not done properly). Burning-in parts of a difficult image is equally allowable (A.A.did it too!) but again, the result must not be obvious. Overdone, it will spread into other areas and give the game away. Burning-in is an art and, like dodging, needs practice, practice and still more practice.

stops down and pre-expose a 10 x 8 inch sheet in doubling steps, e.g. two, four, eight seconds, etc. The results should look similar to a darkroom safe-light test (see p. 97).

The change in high value density should be barely visible, but too much pre-exposure will bring a zone VIII down to an unpleasant muddy VII. By selecting a pre-exposure flashing time to give the required (or hoped for) reduction in density range, a softening of the black tones can be achieved – or density (grey) added in the high values. When printing large sizes, where the negative to paper distance is more, say, than 24 inches, one plastic cup may suffice. Otherwise, with smaller prints, try doubled cups, one inside the other. But like all these tricks, they need to be practised time and time again. Incidentally, the cup that I use is one of the shiny white kind of cups, with ribbed sides, but the soft foam plastic types will work just as well.

Barry Thornton also discusses these techniques in his highly successful book *Elements*[6], and adds an interesting mid-development 'post-flashing' method. This involves taking a print out of the developer about halfway through the nominal time, wiping the surplus developer off the surface before briefly exposing the print to a low light source and returning it to the developer. The result is similar to that gained by pre-flashing, namely the lowering of out-of-range tones, i.e., values beyond zones IX or X, to introduce some texture or tone to otherwise featureless parts of the image. Overdone, the result can be a sort of solarisation – not a catastrophe but a legitimate art form.

Fine tuning of contrast can also be achieved with a colour enlarger, using magenta to produce a high contrast image, or yellow filtered light to soften the image contast – or with combinations of both. The dual colour filter mode usually calls for longer exposure times, while there is less need to adjust the exposure for changes in contrast settings. A futher advantage of using a colour enlarger, is that it allows almost continuous control of contrast grades compared with the nominal ½ grade steps attainable by the Ilford, Kodak or Agfa filtration systems.

Variable contrast (VC) emulsions has come a long way since 1940, when the then scientific Director of Ilford Company, Mr. Frank Forster Renwick, presented the Multigrade process at a meeting of the Royal Photographic Society in London. Although research into the possibilities of making variable contrast emulsions had begun in Ilford's laboratories in autumn 1936, it was discovered that the German scientist Dr. Rudolf Fischer had already proposed the idea and obtained a patent for it (in England!). in 1913. A similarly dated patent of Dr. Fischer's, for chromogenic development, led to the invention – by chemists in Agfa and I. G. Farben – of 'Agfacolor Neu' using colour formers incorporated in the emulsion, as distinct from Kodachrome which uses colour forming developing solutions.

Dr. Fischer's breakthrough was the basis for all of today's colour films, including most colour papers and the monochrome 'silverless' films, Kodak CN 400 or Ilford's XP2-Super.

There is a veritable plethora of VC papers on the market now, available in several kinds of surface and weight, and manufactured in many different parts of the world. I can see absolutely no point in using single grade papers, two stage developers or other means. Apart from the storage aspect, it must be more cost effective to use one type or make of paper. Among the many recently introduced

[6]*Elements, Barry Thornton, 1993; Creative Monochrome, Croydon*

Drop-in burn cards
with various holes

Black
or
middle grey

Offset recess, with
thumb hole

White

'Big Burner' - for burning in parts of a difficult image.

monochrome products, Ilford's *Portfolio* 44 M (pearl finish) gives the appearance of a heavyweight fibre based paper and is excellent as a low cost exhibition paper. The pre-printed postcard sized version is ideal for sending mini-prints of one's favourite images to friends and enemies, relations or recalcitrant magazine editors.

It is encouraging to note that while some photo-industry pundits are predicting the demise of conventional silver halide photography, others are still beavering away producing ever new and improved films, papers and chemicals, Meanwhile, cameras just get quirkier!

Nº 15,055 **A.D. 1912**

Date of Application, 27th June, 1912—Accepted, 27th June, 1913

COMPLETE SPECIFICATION.

Improvements in or relating to the Production of Photographs in Natural Colors.

I, RUDOLF FISCHER, of Beymestrasse 20, Steglitz, near Berlin, Germany, do hereby declare the nature of this invention and in what manner the same is to be performed, to be particularly described and ascertained in and by the following statement:—

5 My invention relates to the production of photographs in natural colors.
Various methods have been proposed to utilize the oxidising properties of various bodies in connection with the production of coloured photographs. For instance leuco-bodies of organic compounds have been employed in conjunction with one or more nitrogen and oxygen groups which can be readily
10 eliminated, for the production of sensitive layers or coloured photographic images, while coloured prints have been obtained by exposing a chromium di-oxide layer under a negative and developing the image so formed by means of a solution of an alkaline bi-sulphite and an organic compound which is oxidisable into a colouring matter by the chromium di-oxide.
15 It is well known that by developing exposed films of halogen-silver in suitable solutions, monochrome pictures can be directly obtained, the exposed halogen-silver oxidising the substance in the solutions to an insoluble or comparatively insoluble coloring-matter which is precipitated on the reduced silver.
A familiar example of such colour development is found in the case where
20 an alkaline pyrogallol developer is employed without any preservative such as sodium sulphite. Amongst other substances which act in a similar manner may be mentioned indoxyl, thioindoxyl, hydrochinone and alpha-naphtol, paramidophenol and xylenol ($C_6H_3(CH_3)_3OH$), paramidophenol and alpha-naphthol, dimethyl paraphenylenediamine and alpha naphthol, dimethyl paraphenylene-
25 diamine and phenol, also toluylenediamine,

$$NH_2$$
$$CH_3$$
$$NH_2$$

diamidodiphenylamine ($NH_2.C_6H_4.NH.C_6H_4.NH_2.$) and other diphenylamine derivatives, and generally those bodies which while acting as developers also produce a more or less insoluble coloured oxidation product. Hereinafter this
30 mode of development will be termed "color development", and the substances causing the same "color formers".
According to my invention I utilise this stronger oxidation capacity of exposed halogen-silver as compared with that of unexposed halogen-silver for

[*Price 8d.*]

Reproduced from: The Illustrated History of Colour Photography (p.136);
Jack H. Coote, Fountain Press Ltd., Surbiton, England, 1993

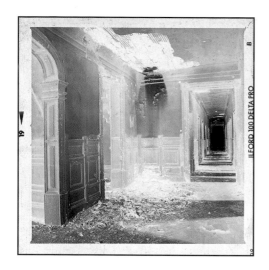

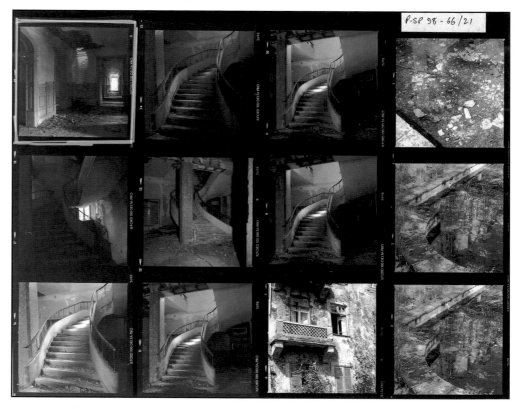

Negative Data
Image: Hotel 1st Floor
Format: 6 x 6 cm
Camera: Hasselblad 503 cx.
Lens: 1:3.5/60mm Zeiss Distagon
Film: Ilford Delta 100
Developer: Ilford Perceptol

Print Data
Enlarger: D2 Aristo cold light
Lens: Rodenstock 105 mm APO
Fine print: Ilford MG IV-FB
Developer: Amaloco 6006 1:7
Toner: Kodak Selenium 1:20
Mounted size: 14½ x 14½ inches

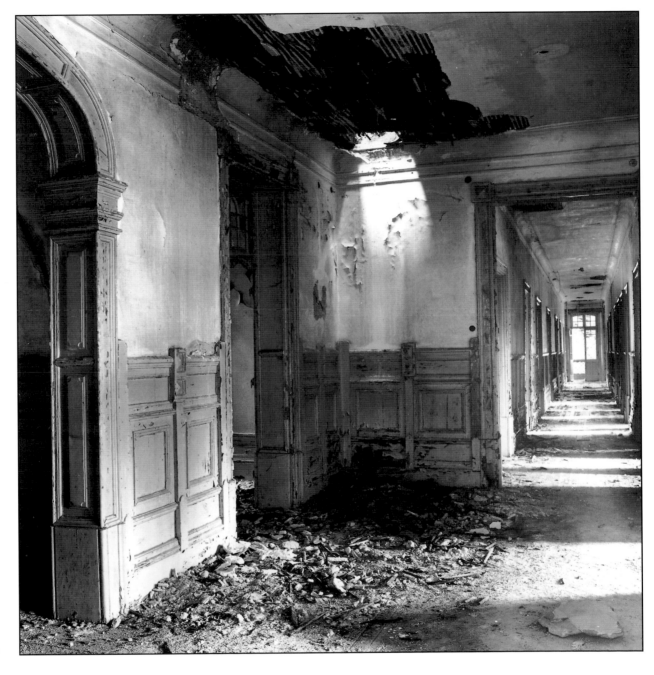

Hotel 1st Floor

THE FINE PRINT
Ceboletta Mesa

While driving around in the north-west corner of New Mexico one day, I took a road that skirted a wide valley, thickly overlaid with crispy black lava that looked as if it had only just cooled down. About a thousand years ago (blink of an eye, geologically speaking) volcanic eruptions in the region had covered hundreds of square miles with ashes and lava. In the more distant past there had been over thirty active volcanoes dotted around the countryside, though surely not all spewing lava in unison. It was easy to see why the Conquistadors gave this place the name *El Malpais* or 'the bad country'. Rangers from a nearby national monument station conduct guided walks (seven and a half miles, one way) across the lava-encrusted valley floor, following an ancient Zuni-Acoma trail – a route the early Spanish explorers had also trodden. But how, I wondered, had they crossed it; strong boots are definitely needed to walk on that obsidian, broken-bottle surface!

Ceboletta Mesa is a dream landscape for poets, painters and photographers, vistas to belie the grim name of the lava-blackened valley beneath. There are sheer-walled mesas and bluffs rising high on either side of the *Malpais*, with a liberal sprinkling of junipers to relieve the stark contrast. Though there was plenty of colour beneath the golden sandstone cliffs, a giant tree shadow arching across a group of boulders simply cried out for a black and white rendering. Topped with fresh snow – the metaphorical icing on a monochrome cake – the rocks looked as though they had just tumbled up against the trees. It occurred to me that if it were possible to make a time-lapsed film of a scene like this, letting it run for thousands of years, trees would pop up and disappear again like a jack-in-the-box, while the bigger rocks would stay relatively still. Only a major rock fall or an earthquake would significantly change the landscape.

For reasons best known to my inner-self, maybe influenced by the geology, I visualised this motif not as a normal landscape, but as a detailed abstraction of it in black and white. A more general view made with the wide-angled 60 mm Distagon, and a colour transparency (Fuji RDP) in the Plaubel Makina 67 were not as interesting. The Hasselblad's quasi-macro 120 mm Planar lens was the right choice, using a middle yellow filter (Heliopan # 12) to lighten the mid-range tones somewhat.

Looking as though it had just cooled

Presentation case with An American Portfolio
and statement (note embossing stamp)

PERMANENCE WITH AGFA SISTAN

Whilst recognizing that black and white resin-coated (RC) papers may never equal the archival stability of fibre-base (Baryt) papers – assuming proper processing in both cases – there are measures to improve the life expectancy of RC papers. In addition to selenium toning (which can be used with RC papers, contrary to popular belief) a post-wash, final bath of Agfa-Sistan will help protect the silver image against oxidation.

Sistan is not a conventional toner; it is a potassium-thiocyanate solution. If oxidized silver compounds form, Sistan reacts with them to form silver-thiocyanate which precipitates back onto the silver particle being attacked. As a compound it is transparent and resists oxidation. It not only prevents silver compounds from migrating through the print ("silvering out") but uses them to build up a protective barrier (see also Ctein; Post Exposure).

Agfa recommends the careful application of Sistan according to instructions; too high a concentration of Sistan (>25 ml to 975 ml water) can lead to marks on the image surface that appear only after a period of time, perhaps days or weeks, especially if the prints are stacked together. This can be prevented by wiping dry both sides of a print before air drying. Crystaline deposits resulting from Sistan treated prints on the rollers of Infrared drying machines should also be thoroughly cleaned after use.

The film was an FP4 exposed at EI 50, developed in Perceptol at the unusual dilution of 1:1½. In those days, Ilford's powder form developers came in 600 ml packs, so I revised the development times to allow three 500 ml fillings of a Jobo 1500 tank. Thus, one tank-filling contained 200 ml developer to 300 ml water. With two films per reel, this let me develop six 120 rolls for about £1.50. There is probably some good Scottish blood mixed with my old Viking stock. This arrangement worked well for many years, until Ilford went 'continental' by introducing one litre chemistry packs. But why stick to the rules all the time – I frequently break them!

While preparing a group of images known as *An American Portfolio* for an exhibition at the Valentin Linhof Gallery in Munich, I decided to print *Ceboletta Mesa* on Kodak Elite. This was a relatively new material at the time, produced, it was said, at Ansel Adams's request for a 'home grown' premium quality paper to compete with Oriental Seagull.

As with any other fine print, the making of *Ceboletta Mesa* needed many stages. It was obvious from the full negative work print that a deep shadow behind the nearest rock would need some dodging. Also, I figured that the cliffs behind, and part of the foreground, might need some extra exposure. The next step was to make another work print using these burns and dodges. This was annotated (see print data) and filed.

A series of test strips was then made to see if these various steps would work out as planned. The final step was to print the full negative format on a 20 x 24 inch sheet and develop it in Dektol 1:2 at 20°C for four minutes. I use a tray warmer at most times of the year, to hold developer temperature to a nominal 20° C. Happily, my home darkroom is in the cellar, which makes it easier to maintain temperature all the year round. Poor temperature-control can lead to inaccuracy in selecting the appropriate paper grade for the best range of tones and contrast.

When processing fibre base papers to archival standards, I use five trays: developer, water to rinse the print, stop bath, and two fixer baths. With RC papers,

of course, only one fresh fixing bath is needed. The between-stage washes help to prolong the life of chemicals. When using the old, strong ammonia-smelling types of fixer, a well-ventilated darkroom is essential especially for asthma sufferers. Fortunately there is a new generation of user- friendly chemicals available, such as those produced by Amaloco in Holland, marketed in the UK by Fotospeed.

I keep all trays, measures and paper tongs dedicated to one chemical; they are never swapped and always cleaned after every printing session. I prefer to use stainless steel paper tongs fitted with plastic end caps to avoid scratching the emulsion surface – which, in any case, should never be touched. It is horrifying to watch others poke around in the developer as if they were frying sausages and chips! To lift a print out of a tray, I grip the print on one corner only with the tongs pointing towards the centre of the image, allowing surplus chemicals to flow off the diagonally opposite corner. With bigger sheets, I hold the adjacent corner with my fingers. Handling a print at this and any other stage – wet or dry – needs great care, once a print is kinked it stays so; nothing will ever flatten it out again.

Washing to an archival standard is the next most critical phase in the production of a fine print. To ensure thorough removal of fixer and fixer-clearing residues from the highly absorbent base of a quality fibre paper, I use a Nova Archival Washer; this can hold up to thirteen 16 x 20 inch prints. Three hours at a moderate flow rate, about half a litre per minute at 20°C, should suffice to reach archival standards. Following a late-night printing session, I have occasionally left a batch of FB papers standing in the archival washer (water off) until next morning without problems, although I hesitate to recommend this for every paper marque.

After three days of drying on home-made nylon net covered frames (see panel, p. 114), the prints are laid in a sandwich of two 1.7 mm thick, dry mount boards and placed in a Seal Masterpiece 210 press for five minutes at 45°C. This renders the prints smooth and flat before hot mounting at 75°C with Seal Archival Mount on a sheet of Bainbridge 100 % rag (cotton) mount board.

For a limited portfolio, I now prefer to use standard sized sheets leaving an ample border for an embossed monogram. The prints are not mounted, but attached rather like one used to mount postage stamps, with an acid-free paper tape as shown on p. 115. An alternative, ultra-archival method uses Japanese rice paper strips attached to the back of a print. Each unmounted print is signed and dated on the reverse side, placed in a Mylar sleeve and stored in a collectors' presentation cassette together with cotton gloves for handling the prints. A statement, printed on archival quality paper, indicates when the edition was produced and how many sets were made.

I have used this chapter to describe, albeit briefly, my darkroom methods for making a fine print – what Ansel Adams called an 'expressive' print in his original and definitive trilogy. However, almost by default now, fine printing is considered to be the art of producing monochrome pictures with Adams-like quality, a criterion that has led to an over-emphasis of techniques. Though it requires much skill and effort to produce a photographic 'masterpiece', when the result is admired solely for its technical brilliance I believe it is time to say: 'Yes, but does it have any artistic appeal?' Irrespective of the wondrous and diverse skills applied, fine print is sterile without a generous measure of aesthetic, emotional or poetic depth.

FIXING TIPS

There are two significant phases in the fixation of photographic materials:
1. The conversion of insoluble silver halide (i.e. not reduced to metallic silver) into soluble compounds, and
2. To dissolve out these soluble compounds from the emulsion
Fresh, strong fixer and the shortest effective time is the key to permanence.

Some Fixing Do's and Don'ts
• **Always** use a stop bath – it helps to maintain the fixer's acidity for proper fixation. But let the stop drip off a print first before dunking it in the fixer.
• **Do not extend** the manufacturers' recommended fixing time; this usually includes a safety factor to ensure adequate fixation – assuming fresh fixer. Extended fixing can even result in image etching, visible in the higher values.
• **Never** under-fix; this is almost as bad as overdoing it.
• **Always** agitate thoroughly and ideally, fix only one print at a time.
• **Do not exceed** fixer capacity, which is limited by the build up of silver residues. For short-term commercial use, the limit for FB papers is ca. forty 8 x 10 inch prints per working strength litre of fixer; for longer term stability, a much lower limit is recommended, ca. ten 8 x 10 inch prints per working strength litre.
• **Avoid** a hardening fixer – it reduces washing efficiency.
• **Two-bath fixation** increases fixer capacity and provides for greater image permanence. Coupled with a hypo clearing aid, e.g. Ilford Galerie Washaid optimum permanence is possible (see Washing Tips, p. 114). The two-bath system is a process based on starting with *two freshly mixed* fixer baths. Prints should be immersed in bath # 1 for *half* the manufacturer's recommended time then transferred to bath # 2 for the remaining period.

When bath # 1 capacity limit is reached (forty prints 8 x 10 inch per working strength litre) it should be discarded and replaced with bath # 2. Mix a fresh second bath and repeat procedure if the number or area of prints again exceeds these values.

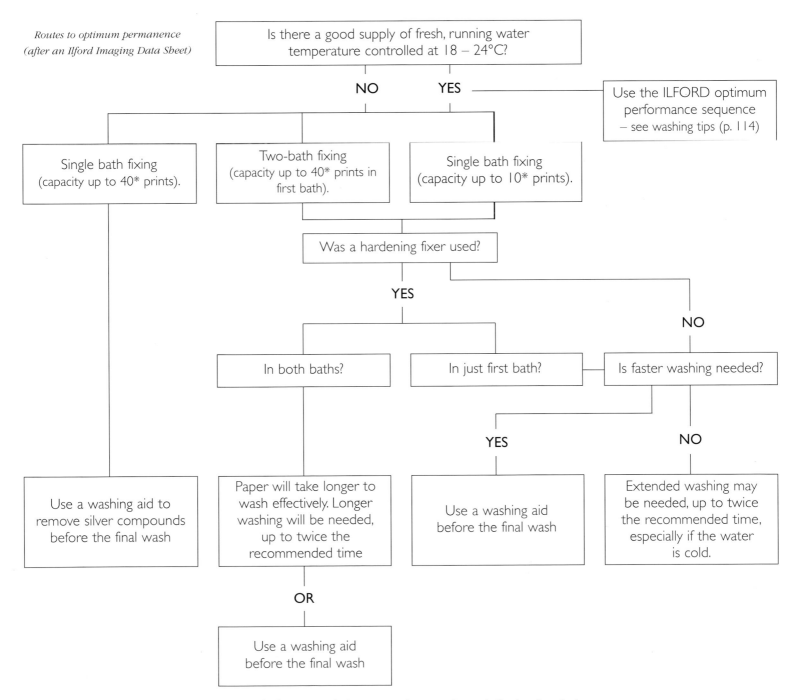

*Routes to optimum permanence
(after an Ilford Imaging Data Sheet)*

Is there a good supply of fresh, running water temperature controlled at 18 – 24°C?

NO YES — Use the ILFORD optimum performance sequence – see washing tips (p. 114)

Single bath fixing (capacity up to 40* prints).

Two-bath fixing (capacity up to 40* prints in first bath).

Single bath fixing (capacity up to 10* prints).

Was a hardening fixer used?

YES NO

In both baths? In just first bath? Is faster washing needed?

YES NO

Use a washing aid to remove silver compounds before the final wash

Paper will take longer to wash effectively. Longer washing will be needed, up to twice the recommended time

Use a washing aid before the final wash

Extended washing may be needed, up to twice the recommended time, especially if the water is cold.

OR

Use a washing aid before the final wash

Note: check prints regularly to ensure they are adequately fixed and washed

DRYING FIBRE BASE PRINTS

Make a drying frame out of simple 5/8 inch square section wood – any wood as long as it doesn't warp. Make inside frame dimensions to suit your maximum paper size. Brace corners with four pieces of the same section, stapled and glued in place. Stretch white nylon mosquito netting over the finished frame, and fix with staples. Then cover the edges with L section wood as shown and glue in place.

Place squeegeed print face down on netting, cover print back with two sheets of Ilford Gallery blotting paper and leave two to three days in normal temperatures and atmosphere until quite dry.

WASHING TIPS

In the interests of water conservation, Ilford Ltd (now Ilford Imaging) devised a miserly method of washing fibre base (FB) paper instead of long-accepted, lengthy wash times. This calls for one minute rapid fixing (dilution 1:4) followed by a thorough first wash of five minutes and ten minutes in Ilford Galerie Washaid for optimum permanence, then five minutes in fresh running water at about 20°C. The Amaloco version of this procedure suggests one minute in X88 fixer (1:4), followed by three minutes in H8 washing agent. Several brands of hypo clearing aids are available for reducing or eliminating fixer/silver residuals:
- Amaloco H8 washing agent
- Kodak hypo clearing agent
- Ilford GalerieWashaid
- Tetenal Lavaquick

Amaloco H8 washing agent is a concentrate which should be diluted 1:7 parts water for use in a tray or archival washer. One litre of working solution will treat about eight sheets of FB paper 20 x 24 inch.

Kodak hypo clearing agent is a powder mixed with water to make a stock concentrate. It can be kept in an airtight glass container for up to three months. Diluted for each printing session, working solutions (1 to 4 parts water) cannot be left for longer than twenty-four hours and must be discarded even if the capacity (about ten prints 10 x 8 inch, per litre) is not used. Clearing time is normally three minutes, or one minute if surplus fixer is rinsed off beforehand.

Ilford Galerie Washaid is a ready-mixed concentrate to be diluted 1 to 4 parts water. Used as described above, two litres of freshly diluted Washaid will treat about eight 20 x 24 inch FB prints. Storage of diluted clearing agents is questionable; two months may be the limit with Galerie Washaid.

Tetenal Lavaquick is also a concentrate, and should be diluted 1:19 parts water. After a brief rinse, five minutes in Lavaquick will shorten wash times by up to 50 %. Two litres of working solution is enough for twelve 20 x 24 inch prints and will keep for up to six weeks. A burst of nitrogen (Tetenal Protectan) before closing the container will delay the onset of oxidation.

MOUNTS, MATS AND FRAMES

• Use an acid-free mount board, e.g. Bainbridge, that matches the lightest tones in your print, replace with. a snow-white board for a cold tone print.

• If hot mounting is not possible, or desired, use two strips of Neschen P90 tape (or rice paper) to attach print as shown. When hot mounting prints, look out for fragments of card or dust under the mount paper; debris leaves a nasty bump in the print surface. Unseen inclusions in the card itself can also cause strange lumps in a finished picture.

• Use same tone acid-free (100% rag) one and a half mm thick mat board, for example. Bainbridge *Artcare*.

• In an ideal world, mats are cut with a machine, e.g. from C+H or a Keen Cut *Ultimat Gold* (best of its kind). Cut the 'window' to leave about a half inch margin all round the mounted image. With practice a 'free-hand' Dexter cutter works well too. Always use a fresh cutting blade. It should be replaced when the bevelled edge has a rough or fluffy appearance. This can also happen if the board beneath becomes heavily scored, thereby derailing the blade. A fluffy edge can be dressed *lightly* with a ladies fingernail emery board. Use a 'boner' to burnish all bevelled edges, or the back of your fingernail – but watch out, it burns!

• There are many framing options for showing your work. Some galleries favour simple wood frames for their neutral effect. Consider also plain aluminium frames, e.g. Nielsen silver matt, profile #15. Glass presents a problem with reflections in some locations, but it does protect the picture. Standard window glass ca 1 ½ mm thick is adequate for most exhibition purposes. Non-reflecting glass kills the brilliance of an image, however. There is also some very expensive, low light-loss UV protective glass.

Neschen SH tape

Alternative mounting with Neschen P90 tape

Hot mount with Seal Archive Mount

To elaborate this thread; when I look at a painting, it is the subject and how the artist interpreted it that interest me, not whether the colours were applied with a palette knife or brush. The medium is usually secondary to my appreciation of the piece. Similarly, if a photograph can catch and hold a viewers' eyes without being viewed as a photographic image, then it has made a quantum leap from being just another picture. You don't need a fine print to do this, it could be a simple RC enlargement, but if it speaks to the soul, amen.

Of the twenty or so images within these pages, the subject of this chapter, *Ceboletta Mesa*, would be my choice to illustrate artistic appeal. The exhibition piece was made to the best of my ability as a fine print, but whether it qualifies as fine art is a moot point and difficult to judge on a printed page.

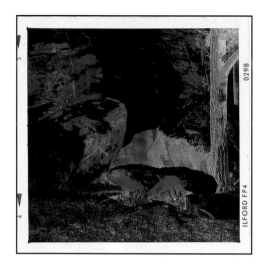

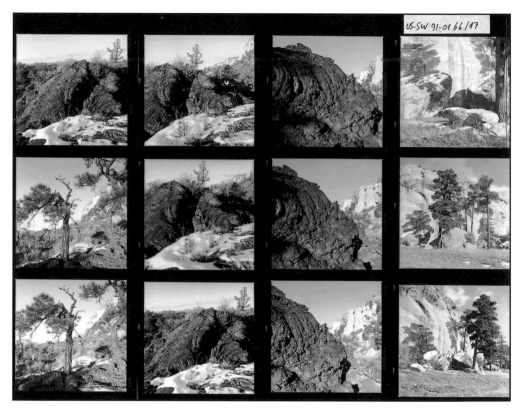

Negative Data

Image: Ceboletta Mesa
Format: 6 x 6 cm
Camera: Hasselblad 500 CM
Lens: 1:5.6/60mm Zeiss Planar
Film: Ilford FP4
Developer: Ilford Perceptol

Print Data

Enlarger: D2 Aristo cold light
Lens: Rodenstock 105 mm APO
Fine print: Kodak Elite
Developer: Dektol 1:2
Toner: Kodak Selenium 1:20
Mounted size: 15½ x 16 inches

Ceboletta Mesa

TABLETOP PHOTOGRAPHY
Peppery Love Affair

Shall we dance?

One day while pottering about in the darkroom doing nothing in particular, my wife called me to the kitchen where there was something special to see, as she warned: 'before it's too late'. The objects turned out to be curvaceous green peppers that were heading for the chopping board sooner or later. It was immediately clear that *later* was the only option. Peppers are ideal subjects for tabletop photography, indeed, any vegetable or fruit – wild or cultivated – can be arranged to make interesting motifs. These two were in fine condition, not a wrinkle or blemish to be seen on their bright shiny skins, as in Edward Weston's sensuously beautiful peppers.

While grouping them in various poses, a 'twosome' gave me the idea of a loving couple in a dancing mood. After many attempts, I succeeded in joining the pair invisibly with a toothpick and tiny pieces of Plasticine, but still they kept toppling over just as the shutter was opening. Eventually, patience was rewarded with this trio of pictures.

In one of his *Daybooks*, Weston remarked on similar difficulties, except that he also had earth tremors to cope with – regular events along the geologically active Californian coast where he lived. Another hazard was his son Brett, who ate two of the peppers before Edward could photograph them.

Your place or mine?

I used the Hasselblad 120 mm Planar lens to focus about eighteen inches from the peppers, which were tilted a little to correct the perspective. To make sure that the kitchen table edge was not visible, the tripod was set on maximum extension for a more elevated view, while the net curtained kitchen window provided ideal diffuse midday illumination with a range of four tones across the motif. A meter-reading from a grey card held cautiously in front of the peppers gave the required settings, to which I added one f-stop more light to compensate for the fully extended lens. Though I knew this 'rule of thumb' would work, just to be sure I checked it on a Hasselblad Close-up Calculator. This handy slide rule gives f-stop or shutter adjustments for a wide range of lens and spacing ring combinations.

Normally, in macro photography with a 35 mm camera and the TTL metering system, any lens extension is automatically compensated for in the exposure.

The party is over!

Negative Data
Image: Peppery Love Affair
Format: 6 x 6 cm
Camera: Hasselblad 500 CM
Lens: 1:5.6/120mm Zeiss Planar
Film: Kodak TMX
Developer: Atomal 1:1

Print Data
Enlarger: D2 Aristo cold light
Lens: Rodenstock 105 mm APO
Fine print: Ilford MG IV-FB
Developer: Amaloco 6006 1:7
Toner: Kodak Selenium 1:20
Mounted size: 11½ x 12½ inches

I chose to load a Kodak T-Max for this image, and set the Pentax V Spotmeter at ASA 80 for an exposure based on fifteen minutes development time at 20°C in Agfa Atomal diluted 1:1. However, ca. twelve minutes development would probably have resulted in less dense negatives.

The image shown here was printed the next day on Ilford Galerie grade 3 and almost immediately sold to a human loving couple! A second set with fatter, plumper peppers was made as a skit on the top politicians in Germany at the time – but please don't ask me for names.

Tabletop photography is an inexpensive, delightful way to practice still life composition and lighting techniques in the comfort of a 'home studio' – or to experiment with different film types. It is an activity that people confined to a wheelchair could excel at using a lower table for ease of access, or even the floor as a work surface. Photography is being used increasingly as a therapeutic recreation by social rehabilitation groups where indoor photography can open doors in closed minds and let fantasies range with still life subjects and modelling clay. One only has to look around the art galleries to see how much indoor work was done by painters, using everyday things as motifs to exercise composition perhaps, or new brush techniques – or that they simply didn't have the means to work en plein-air.

When asked to judge at local photo-club competitions, I am frequently disappointed to see how few members submit a still life – either as a tabletop close-up or a normal subject. Nude studies are even scarcer, but perhaps this is just the rather tight-laced Bavarian scene; hand-processed black and white prints are rarely presented. Do-it-yourself black and white printing used to be de rigueur in amateur or club photography, but supermarket 'Special Offer' colour prints seem to have taken the place once held by home processing. Things are turning full circle however, as printing digital images from the personal computer gains popularity.

I made an exhibition triptych entitled a Peppery Love Affair (see panel) on Oriental variable contrast fibre base paper which was developed in Agfa Neutol (liquid) WA, a neutral to warm-black developer with excellent lasting properties. The trio of pictures was toned in Kodak Selenium diluted 1:20 at normal room temperature, agitating the prints one by one (at arms length, being asthma prone) until the first signs of tonal change. Depending on the make of paper, it takes some four to five minutes for a treatment that considerably enhances the storage or hanging life of a print.

As regards asthma and other ailments, one should of course take every possible care when working with chemicals in a confined space like the majority of home darkrooms. I am relatively fortunate in having about 30 square meters of darkroom area, but nevertheless the air can get a bit thick when mixing fierce brews like Cibachrome bleach, even with a good ventilator running. Similarly, some fixes, selenium or stabiliser baths can cause an immediate wheeze if one is allergic to such stuff. For an encyclopaedic guide to the toxic side of our magical hobby, Health Hazards for Photographers[7] is full of cautionary tales – some that might even put people off from working in a darkroom with chemicals. Digital imaging evangelists will be crowing over this! But the message is clear: avoid problems by obeying the basic rules when dealing with poisonous substances and take no risks.

The pepper trio is popular wherever it is exhibited, though few viewers understand my alternative title for Pepper #3: 'Get off my back – Edward did it better'. I am surely not the first to have emulated Weston with pepper images – but who better to follow? He showed us the way, a path we should all tread gratefully in the search for artistic expression. And if that path leads to new untried fields, remember that the key to success lies in being truly innovative.

[7] Health Hazards for Photographers, Siegried & Wolfgang Rempel, Lyons and Burford New York, 1992

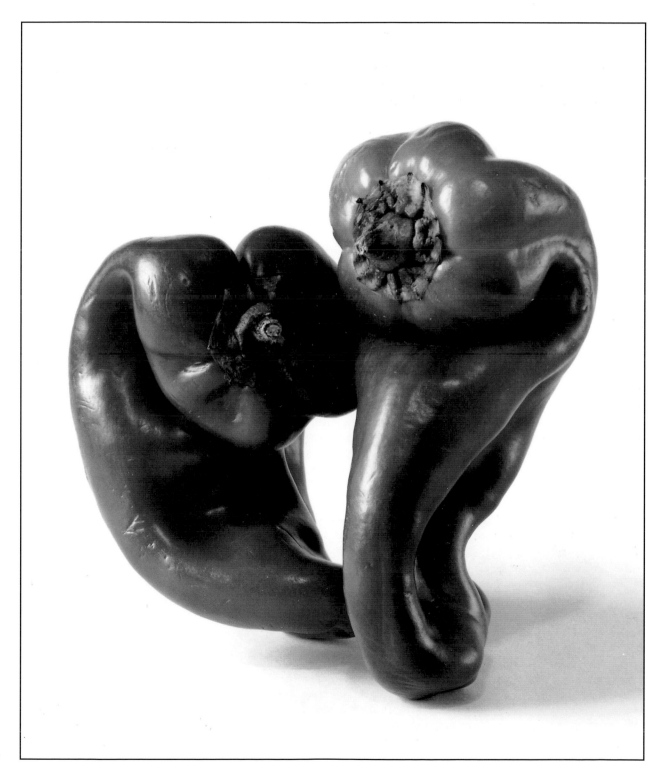

Peppery Love Affair

DUPLICATING WITH POLAROID 55P/N
White Sands Dawn

O f all the desert landscapes in the American Southwest, there is perhaps none more daunting for photographers than New Mexico's White Sands. The highly reflective gypsum surface presents a major exposure problem for films and people alike, especially in the bright daylight and heat of mid-summer. Around dawn is the best time, when the dunes become a wonderland of sugarcandy forms and better still in the winter months, when the sun rises late and rosily over the south-eastern edge of the dunes. I chose to go there in early January, when it can also be *very* cold – and indeed the winter of 1990/91 was one of the coldest on record in New Mexico.

This popular national monument is part of a vast wilderness that extends some sixty miles northwards from Alamogordo, right up to the most recent lava flows in the *Malpais* near Carrizozo. The almost pure-white sands are clearly visible from an orbiting spacecraft hundreds of kilometres above the Earth. Much of this unique desert region is also used for testing rockets and guided missiles, making large areas out-of-bounds to the general public.

While I was out on 'The Sands', planning the next day's photography, a guy came striding past with an impressive looking large-format camera attached to a huge tripod; he was heading quickly westward into the setting sun, hoping, like me, to find pristine dunes untrampled by other image-hungry photographers. But beware of dunes in desert wildernesses! Away from any access roads, it is very easy to lose one's sense of direction; some dunes are high enough to block a view of the horizon. A little practice with a good compass would not be overdoing things.

With a rapidly climbing golden orb lighting the dunes in the east and a pale gibbous moon hanging low over the distant San Andres range, it was a dream landscape – rose pink dunes, their sensuous contours enhanced by purple shadows draped like dancers' veils. There was little time to contemplate the scene, and I was not sure that my efforts had done it justice. Suddenly I saw these rows of selenite crystals and clumps of grass sprouting through cracks in the sun-dried valley floor, lending that all-important three-dimensional effect to the image. One quick hand-held exposure in colour with the Plaubel Makina 67, and the magical moment was over.

Making Polaroid duplicates.

This single image has the novel quality of being equally impressive, either as an Ilfochrome print from the original 6 x 7 cm Fujichrome RDP transparency, or in monochrome via a duplicate made on an extremely fine-grained Polaroid 55P/N film. A 16 x 12 inch print on Oriental VC-FB showed little sign of it being a third-generation image. The difference between them is remarkable: one has a soft romantic appeal, while the other (monochrome version) has greater emphasis on

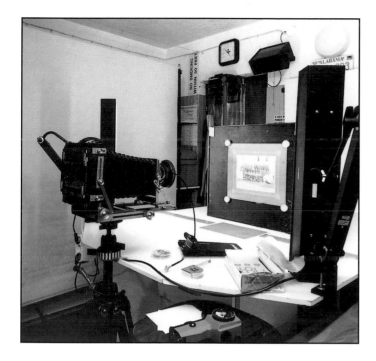

Copying an old print.

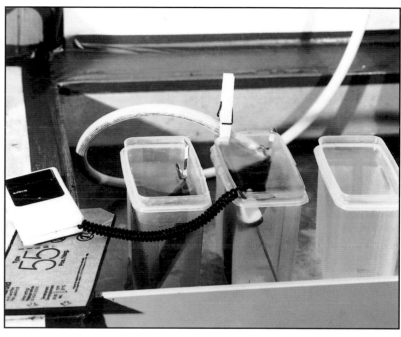

Clearing and washing Polaroid films.

perspective, helped by a more dramatic sky, produced by darkroom manipulation. In its black and white form, the result looks more like an artist's impression of a desert region than a photograph.

Making duplicates on Polaroid 55 P/N through an enlarger was *Kinderspiel* – simple as ABC. First, I fitted a large block of wood with two pieces of aluminium angle to clamp the Polaroid film holder in place (see illustration) and taped the assembly to the work top. For setting up the image in the film holder, I used a piece of photo-paper marked out with the required size. With the enlarger set to a comfortable height for focusing, a Rodenstock 150 mm lens was ideal for copying from 6 x 7 cm into the Polaroid format.

For setting up the image (reversed in the enlarger to make a right-way-up negative) I used a discarded 55P/N print (with a dud negative taped to its back) to simulate the image plane in the holder. Of course one could use a grain focuser on the actual film surface, but this would destroy the negative/positive in the process – a somewhat pointless step. Tests showed that both the LPL diffuser colour head and the Omega's Aristo cold light unit (with 20Y filter) made good duplicates of colour slides on this Polaroid panchromatic film.

Another advantage of duplicating this way, is that one can introduce filter effects: a #22 orange or #25 red for improved tonal separation in clouds; a G1

filter for reduced contrast. A first cut at the exposure can be made by taking a reading for normal Ilford Multigrade IV RC paper on an analyser such as that produced by RH Designs, and dividing the time by four. One could also recalibrate the instrument for work at ISO 50. To obtain a negative with a good density range, the print should be over-exposed by about ⅔ f-stop. Without analysing facilities, the darkslide can also be used to make a series of exposures in the manner of test strips as in normal darkroom printing. Remember that *all* lights, including the darkroom safelight *must* be turned off before the packet's darkslide is opened to make the exposure.

With the darkslide replaced, development is made by pulling the packet through the Polaroid holder as smoothly as possible; jerky motion will cause patchy development. Spring-loaded steel rollers in the holder break a pod containing developer, spreading it evenly between the negative and positive. After waiting the prescribed time (adjusted for temperature variations if necessary – see scale on dark slide) the packet must be opened and the negative separated from its sister positive and developer pod. For best results this should be done as soon as possible, and in subdued lighting. The negative must then be submerged in a clearing solution of 18% sodium sulphite within three minutes of opening the packet.

Development of Polaroid images made in the field, can of course be left until one is back in the darkroom – this is the system's great strength[8]. One must simply ensure on exposed sheets that the developer pod is not knocked during transport with the camera equipment. Take great care when handling the open Polaroid packet, for two reasons:

First, it is a very thin negative by other sheet film standards and is thus easily torn or scratched.

Secondly, if you have sensitive skin, or a cut on any finger, use surgical rubber gloves when handling the negative or pod. I was once careless enough to get some of the developer gel into a wound; it took ages to heal. For ease of handling, the negative can be detached from the packet and developer pod by carefully folding the film along a line of perforations found at each end of the negative.

To complete the process, I use three refrigerator food boxes, in section ca 2 x 6 inch and 6 inches deep, placed side by side in the sink (see picture). The first container is filled with 18% sodium sulphite, a clearing agent that removes a filmy substance from the negative surface in about one minute. The middle box is used to wash the negative while the third contains distilled water with a 2% wetting agent, e.g. Agepon or Ilfotol. A small sheet film hanger (Kinderman make) attached to one corner, makes handling a little easier. Two to three minutes washing in running water is adequate, but make sure it is not too warm; more than 24˚ will soften the film and make it more susceptible to damage. A further minute in the distilled water completes the process. When all proceing is finished, I pour the clearing agent though a large coffee paper filter back into the storage container; this way it keeps from ages.

Occasionally village folk ask me to make copies of old black and white family portraits, or local historical events, which I am pleased to do when there is no original negative available – and no copyright problem. Polaroid 55P/N is an ideal solution for making quick, but superb negatives. The results are often astonishing, as the detail on this page shows. Portraying veterans of the Franco-Prussian war of 1870-71, the picture (printed perhaps from large format glass plate negative) was in poor shape. My copy negative was good enough to enlarge to 12 x 16 inches on Ilford MGIV FB, with remarkable clarity and sharpness.

For jobs like these I use a pair of daylight strip-lights ca. 250 watts, the kind used with a repro-camera for copying. A heavy steel-surfaced board is used to hold the photograph, engraving or print flat with magnets, while an office notice board (non-permanent sticky surface on cork) serves to hold old and creased maps or papers flat. Depending on the original's size, I adjust the lens to subject distance, and/or lens focal length (150 or 210 mm) to give the image size I need on the focusing screen of a Gandolfi Precision 4 x 5 inch camera. Exposures on the Polaroid 55P/N film under these lighting conditions are usually quite long and must include a correction for lens-to-film extension beyond the chosen focal length. In the example shown here, I used a 47B (blue) filter to boost the faded print contrast, requiring even greater exposure adjustment and take into account the relatively moderate reciprocity law failure.

Group portrait, detail enlargement - from a fourth generation image!

Negative Data
Image: White Sands Dawn
Format: 6 x 7 cm
Camera: Plaubel Makina 67
Lens: 1:2.8/80mm Nikkor
Film: Fuji RDP Transparency
Developer: Tetenl 3-bath E6
Duplicate: Polaroid 55 P/N

Print Data
Enlarger: D2 Aristo cold light
Lens: Rodenstock 105 mm APO
Fine print: Oriental VC-FB
Developer: Agfa Neutol WA 1:7
Toner: Kodak Selenium 1:20
Mounted size: 11 x 13 inches

It is sometimes necessary to move the lamps away from the usual 45 degree lighting angle, especially if the picture has a semi-matt surface; this shows up as a myriad of tiny reflections in a copy print. The problem may be overcome by positioning the lamps farther round, to about 60 degrees relative to the repro-board and subject (30 degrees to camera.) An expensive alternative is to use polarising gels, but this is a technique[9] applied more in reproducing colour work, for instance oil paintings where there is often considerable surface relief – especially in palette knife paintings. Combined with a polarising filter over the lens, reflections such as these are completely eliminated. The Kodak handbook on copying and duplicating, referenced here, is another must for the serious studio worker.

[8] *Polaroid Black & White Land Films; A Guide. Focal Press, 1983.*
[9] *Copying and Duplicating in Black and White and Color, Kodak Publication M-1, CAT 152 7969.*
11-85-Minor Revision; Eastman Kodak Company, Rochester, NY

Near Jasper, British Columbia
Polaroid 55P/N 5x4 inch duplicate of a 6x7 cm Fujichrome RDP transparency, printed on Ilford MGIV RC using split-grade methods; 6.5 sec at grade 5, followed by 6.5 sec at grade 0; plus 2 sec at grade 0 for the clouds; plus 3 sec at grade 5 for the top of the sky.

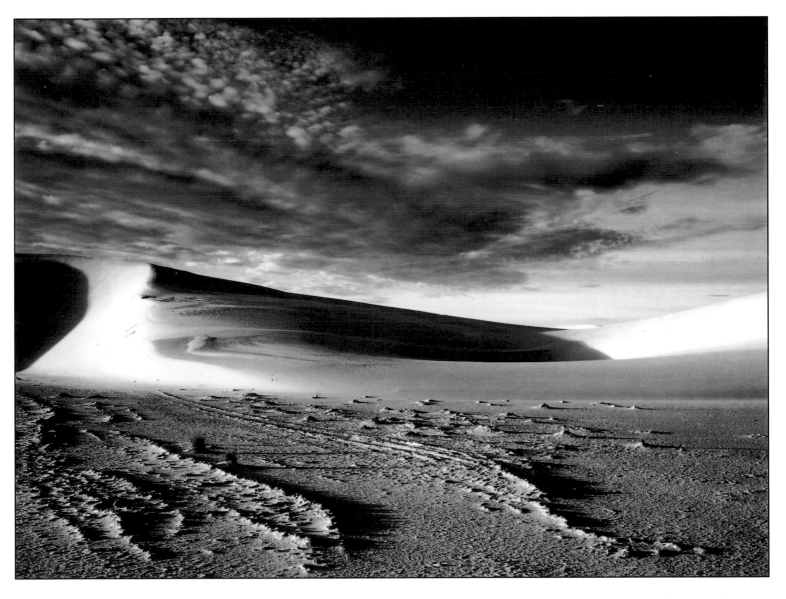

White Sands Dawn

MORE DUPLICATING

Children's Games, Andorra

Whenever someone begins to bore me with facts about the latest all-singing, all-dancing, super automatic motif-signalling gizmo, I show him (it is usually a 'him') this picture made in 1957. It was seen on one of the many trips my wife and I made through France on a 125cc BSA Bantam motorcycle, driving over the Pyrenees up to 2300 metres in altitude, into Andorra. This was some achievement I thought, until Tour de France cyclists came storming by on their way to tackling similar, dizzying mountain passes using pure muscle and lung power.

All this seems like part of a previous life to me now, and indeed most of these early films were to all intents and purposes lost, lying in an unmarked box and in poor condition. I blush now to admit that many of them were simply rolled up with a rubber band around them! Though they were left soaking in soft water for ages, they remained steadfastly curled. There were no remarkable or earth-shattering images on these old films, however – except for a few that were cut into sections and luckily still flat in a traditional Kodak yellow photo-finisher's paper envelope. Among this group of negatives was a nameless 127 format film, scratched and fragile looking, that had been exposed in a 'Purma Special'. Each frame has the classic cushion-shaped form indicative of fairly basic optics. One of the rescued images, that I now call *Children's Games*, was published in the late and much lamented *The Black and White Art Photographer*, Journal Four. On seeing a framed print of it for the first time, a friend thought I had newly acquired a Cartier-Bresson.

The fragile state of this negative worried me ever since rediscovering it. Moreover, its odd format did not fit any of my enlarger negative carriers. The solution was to make an enlarged copy on Kodak Professional Duplicating Film SO 339. As an orthochromatic, extremely fine-grained medium contrast film, it is designed specifically for one-step copying of continuous-tone black and white negatives or positives. More importantly, it does not require reversal processing.

Any conventional enlarger light source can be used to expose SO 339; I used an Aristo cold cathode light balanced with a 20Y filter for variable contrast papers. With a normal tungsten lamp delivering five foot-candles illumination (ca 53 lux) on the enlarger easel, an exposure of forty seconds is recommended as a starting

No batteries required, just gravity!

point for tests. More exposure produces less density, and vice-versa. Kodak also specify a darkroom safelight with a Wratten #1A light red filter over a 15 watt bulb at least four feet away from the film (see p. 93 on safe lights).

I made a cardboard holder for the *Children's Games* negative and used a small print easel (with a matt black surface to minimise back-reflections) for the duplicating film. After setting the Omega height for a 5 x 4 inch enlargement, and stopping down the 150 mm lens to give a reading of 50 lux, a series of exposures across a full 5 x 4 sheet showed that forty-five seconds was about right for my set-up. Note the use of a whole sheet of film; small test strips can lead one to make wrong deductions about optimum exposure times – this goes for all kinds of photographic printing.

Stainless steel kitchen pans make good darkroom accessories

Normally I would use a Jobo ATL-2 Plus Autolab to process sheet films, but as Kodak SO 339 is easily tray processed I used a regular stainless steel professional kitchen pan, ca 12 x 14 inch. This was cheaper than the expensive kind of photo-chemical tray often found in so-called high end equipment catalogues. Metal trays, however, even with careful handling, are easily scratched – deadly for soft emulsion surfaces – so I store them separately in plastic bags.

As the info box shows, development is simple: two minutes in Kodak Dektol 1:1 with continuous agitation at normal room temperature. Contrast is controlled simply by varying the time, a longer development producing a steeper characteristic curve. It is also easy to burn and dodge under or over exposed areas, using normal printing to paper procedures. The rest of the wet process is straightforward: immersion in a stop bath for twenty to thirty seconds, followed by fixing (again with frequent agitation) for up to ten minutes, or half this time with any 'rapid fixer'.

Results were so good on a 5 x 4 inch copy, that I immediately tried the next size up, 10 x 8 inch, using the same enlarger but, of course, with a different exposure time / f-stop settings. Fibre base or RC prints made from either of these duplicates are difficult to distinguish from a direct enlargement made from the original 1¼ x 1¼ inch negative. The 10 x 8 duplicate makes an excellent contact print.

The Purma was a favourite with post-war Fleet Street paparazzi. With a Bakelite body and simple lens (f-6.3, 60 mm), it was the ideal PhD (Push here, Dummy!) camera. Photojournalists liked it because they could roam the streets with a Purma in their pocket and snap pictures without having to worry about focusing or shutter settings. When cocked, its mechanical shutter was ready for release simply by taking off the lens cap. With a fixed focus lens everything beyond ten feet was sharp – relatively speaking.

Being a square format image you could hold a Purma any way up. Moulded on either side of the viewfinder were the words: 'Slow', and held the other way up: 'Fast'. The three shutter speeds of a sheet metal focal plane shutter were purely mechanical, determined by a spring and gravity. Held in the normal horizontal medium mode, the shutter speed was about 1/150th second; turned through 90°, the spring plus gravity gave approximately 1/400th. Rotated in the opposite direction, through 180°, with the spring acting against gravity, the exposure time was roughly 1/25 second. A typically functional British invention.

Looking back over the years with these old pictures, I still think that some of our happiest times in photography were when cameras were simple and the range of goodies limited to a few filters or supplementary lenses. We enjoyed our hobby without the millstone of today's super-technology that takes responsibility for making pictures away from the photographer. Without heart and mind, the creative touch withers and dies.

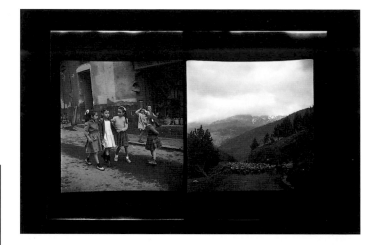

Print Data
Enlarger: D2 Aristo cold light
Lens: Rodenstock 105 mm
Fine print: Ilford MG IV-FB
Developer: Amaloco 6006 1:7
Toner: Kodak Selenium 1:20
Mounted size: 12 x 12 inches

Negative Data
Image: Children's Games, Andorra
Format: 32 x 32 mm (127)
Camera: Purma Special 127
Lens: 1:6.3/60mm Beck
Film: Unknown (HP3?)
Developer: Kodak SO 339

Contact print from a duplicated negative
on 5 x 4 inch SO 339.

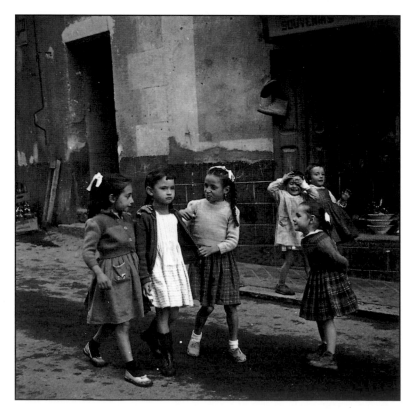

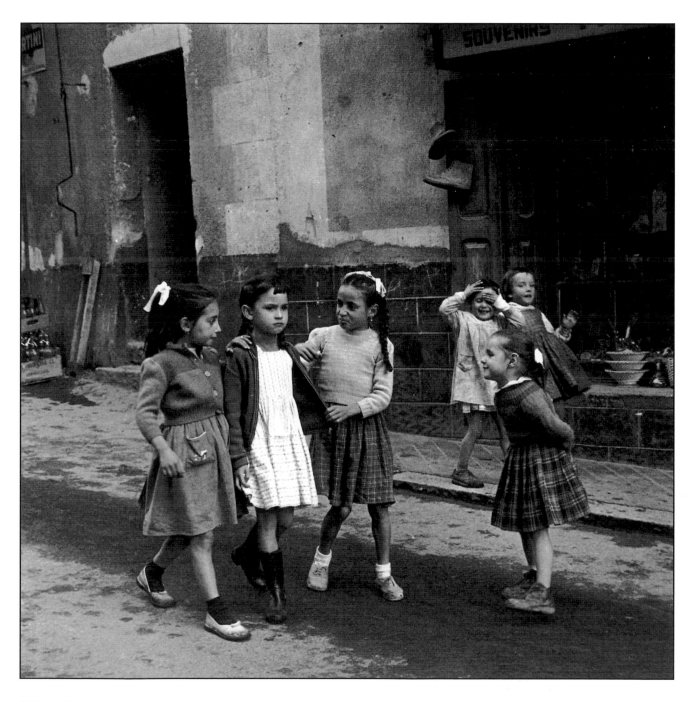

Children's Games, Andorra

A QUESTION OF HANGING

We all like to exhibit our most treasured images from time to time, and I'm certainly not one to hide away saleable pictures. Of course, it's nice to be asked by the local bank manager to hang a little show in the foyer, but the chances of selling to the average bank client are pretty small. People go into banks to get money or put it away (or pay bills) and usually do this as quickly as possible. Maybe fear of a robbery keeps transactions short! Another popular place for budding artists to show their wares, is a doctor or dentist's waiting room but most people are worrying about their aching tooth, or whatever, to care much about art.

Public places – libraries, schools or industrial concerns – offer greater opportunities for exhibiting one's work in large display areas, but still may not attract the ideal viewer or possible customers. One advantage of showing at this kind of venue is that they are often free of charge, except perhaps for drinks and nibbles at the opening reception. But, after years of showing in all kinds of locations (even religious meditation centres) I'm convinced the proper place is a gallery or museum that specialises in photography. Many of these institutions are often more interested in dead photographers than living ones. Assuming the chance ever comes your way to show on such illustrious walls, the waiting time is usually several years.

I solved this lack of good showing space several years ago, by renting a local gallery for a few weeks during the summer holidays – now an annual event that helps spread the word about photo-art, aided by friends in the press.

The layout and grouping of pictures is all important, though this is perhaps easier if the work has a central theme. One of my earliest shows was justifiably criticised by a colleague who said it looked like a production line – fourteen same-sized framed pictures all in a neat, equally spaced row along one wall of a conference room. Next time they were better arranged, with carefully chosen juxtaposition of images in various sized frames. Good presentation assures more than half the success of a show, and it encourages other photographers to do likewise. If you want to attract 'Top People' a professional appearance is crucial.

In a move to pat our collective backs, I firmly believe that photographers care more about the quality of their presentation and archival materials than the majority of abstract paint dabblers or hobby watercolourists. Some of the 'art' exhibitions I've had the misfortune to view have left me speechless with rage over the prices asked for such shoddy workmanship.

Besides the picture titles, an exhibition catalogue should include the image and frame size, and more importantly, the edition number and prices of each print. Avoid hackneyed titles – the place name is enough, or even 'Untitled'. If an image is strong enough, your audience will interpret it for themselves.

Safety is an important aspect. Many galleries use a monorail system into which nylon cords with adjustable hooks are used to hang pictures. Gravity works slowly but inexorably, pushing a carelessly tightened hook down to the end of the nylon cord – and the picture crashes to the floor. Murphy's law states that it will be the best picture! A simple knot will prevent the hook from slipping right through. When it happened to one of mine, a Cibachrome, the picture landed luckily face down. But instead of turning it over quickly to see if the delicate glossy surface was damaged, I tapped the slightly tilted frame to dislodge any remaining glass fragments. That crash haunted me for days.

It is probably advisable to check whether the premises or site owner has adequate insurance cover against personal or third party disaster. If you provide your own insurance, the small-print might require that you or somebody must be in attendance while the show is open to the public. Finally, a brief biography (in a large font for easy reading) listing important exhibitions and other successes should be presented in a similar style frame hanging near the entrance.

On a lighter note, it was not until I started showing in Germany that I understood the meaning of Vernissage used on invitations to a reception. Few know that the Vernissage was an event that took place a day or two before an Academy Salon opening, when the invited artists applied a clear varnish (French:vernis) over their masterpieces. I've often wanted to arrive at such an opening, in atelier smock with a brush in hand, offering to help!

Museum of Art, Huntsville Alabama 1986

Foyer of Linde Co., Munich 1999

IN MY VIEWFINDER ...

"The rare moment is not the moment when there is something worth looking at, but the moment we are capable of seeing."

Joseph Wood Krutch

In the preceding chapters I described how these images were made: how the motif first affected me; how easy or difficult it was to photograph and the methods used. All this goes on as a kind of sub-routine, a debate at lightning speed in the subconscious, where technical data are stored, where the simple mechanics of making a picture are balanced against the artistic content of the subject. The danger occurs when this inner-dialogue begins to lose sight of the original idea – when each new motif is regarded simply as a set piece; another exposure challenge to overcome, another chance to study the subtler points of composition.

Why I saw these motifs in this or that particular way, or what had motivated me is quite another topic – one that could be discussed endlessly. The 'Why?' question is probably the most difficult to answer; indeed, why does anyone do anything? To begin with I enjoy photographing the world about me, recording the places and things that excite my senses, and the people that I meet. Candid snapshots of absolute strangers, however, is not my métier. These twenty pictures were made simply for my own satisfaction, not for any competitive purpose or to render some well-known motif better than A or B ever did. Whether they have something to say about my attitude towards the subject – or about photography – is not my concern. A few have been published; some have been accorded far deeper significance than they had to me at the time of seeing.

My aim is to raise the level of appreciation of an art form somewhat devalued by the onslaught of images in the mass media, and to give pleasure to others via regular exhibitions and lectures. The resonance from these activities continues to grow, boosting public respect for 'straight' monochrome photography. As a remedy for self-doubt, the returns are enormous. It is not all altruism though. An occasional sale of work helps reimburse a considerable material outlay.

Perhaps some of the answers to the questions might be found in the fine arts: painting, sculpture, music, poetry and prose, where a major part of my inspiration lies. My ideals of expression in the visual arts are the landscape painters Constable, Cotman and Turner, and the Impressionists: Sisley, Monet, Cezanne (for still life) and Seurat (for Pointillism). I try to visit as many exhibitions as possible and to remain keenly aware of all forms of expression in the visual arts field, good or otherwise.

Music too, continues to have an inescapable influence on my photography, especially the works of Bach, Debussy, Dvořák, Janáček and Mozart, to list just a few favourites that spring immediately to mind. Life without them would be a wilderness. I enjoy most kinds of music, from ancient to modern, from Buxtehude to the gentle sounds of Stan Getz – perhaps even a touch of minimalist Philip Glass. To mirror my emotions while listening to music is an enduring wish, but some of the sounds emanating from contemporary cacophonists can quickly shatter any dreams of making harmonious images!

With so many influences in the major arts, conscious or otherwise, it is not surprising that my landscapes often show a classical, quasi-romantic interpretation. Even a straight picture like Works Entrance, Ornans takes on a painting-like appearance; my photographs just seem to get this way, without trying. Maybe all those youthful water-colour essays at art school were not a waste of time. At almost every exhibition of mine, someone points to a picture and asks: 'Is that a painting?' irrespective of it being in colour or black and white. This led me to write an article for Hasselblad Forum entitled: 'Looks Like a Painting'.

Naturally, from the world of photography there are untold influences; to be unaware of these would be practically impossible. Cognoscenti say that my American Southwest images appear to emulate Strand, Adams, Evans or Porter, at least in style if not in quality. Although one cannot deny the influence of these distinguished masters – long my spiritual mentors – there was never any intent to copy them. While similarities are almost unavoidable with images of derelict sharecropper's houses, ghost towns and pioneer graveyards, one magazine reviewer of *An American Portfolio* did note a distinct Todd 'hallmark'. To be a proficient photographer is relatively easy; to be original is quite another thing. A recognisable signature is all I ask.

Colour is simple compared with producing monochrome fine art, but don't be misled into thinking: 'I've got black and white photography licked – now let's try

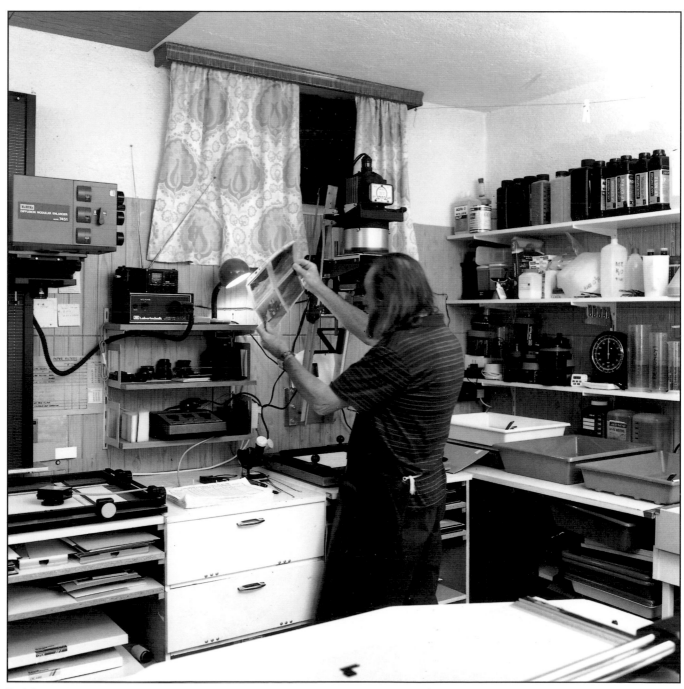

Back home, the work begins ...

colour'. My recommendation is to tackle it from the opposite direction. Learn how to cope with the difficult density ranges of colour transparencies – seeing how they react to filter changes, learning how to mask, dodge and burn – then use this experience to produce monochrome masterpieces with a difference. And on returning to colour printing, you may be pleasantly surprised to find it easier than before. The circle would thus be complete – and continuous.

I aim to maintain this spin, monochrome to colour back to monochrome, to keep the creative adrenalin flowing. After all, it is not the colour or lack of it that counts, but the image; it should work in any medium, silver-halide photography, watercolours or oils – even digitally.

In another of my several lives (at least it seems like that!) in engineering, I learned to appreciate the beauty of mechanical design, and functional perfection. Some of this goes back to pre-war days while studying architectural draughtsmanship. It seemed a drudge at the time, drawing curving steps and architraves, balustrades and columns – perspective studies that remain ingrained and recalled every time I try to photograph a cathedral interior. This has made it easier to previsualise objects in their three-dimensional form and to illustrate them on a flat piece of drawing paper; an essential attribute for any photographer. And as if all this was not enough, an amateur interest in geology and geomorphology led to a special affection for our dynamic planet and its rocks, feelings I love to express in abstract images of land forms.

What was the motivation? Well of course any beautiful landscape or the elegant symmetry of a cathedral nave always moves me – otherwise the cameras would stay in my rucksack. Naturally, what I perceive as an interesting motif may not be so in another's view of the world; a box of Allen screws was once enough to give me a winning picture. A heap of old newspapers or a piece of plastic fluttering in the breeze, for instance – even a trash container might become an attractive motif in my eyes and be imbued with artistic meaning. Some might look askance at this suggestion, but it all depends on the degree of abstraction. Whenever folk ask: 'What kind of things do you photograph?' I usually reply: 'Anything standing still, anything that moves or that moves me'. An over-simplification perhaps, but an honest answer.

This, then, is my credo. It guides me to all kinds of wonderful discoveries in light and shade, form and structure – in the places and things seen, and captured on a myriad of silver halides. Perhaps these few pictures will signpost ways of exploring the world around us and inspire readers to find new means of self-expression. But, I must close with this caveat: possessing all the available 'how to.....' books, and the finest cameras is no guarantee of becoming a good photographer. The art of making great images begins when the heart takes over.

Yesterday's importance; Tennessee, 1982

"The enemy of photography is the convention, the fixed rules of 'how to do'. The salvation of photography comes from the experiment..."
Laslo Moholy-Nagy, 1947

APPENDIX A

List of manufacturers or suppliers named (as of January 2001)

Agfa-Gevaert Limited, 27 Great West Road, Brentford, Middlesex, TW8 9AX

Amaloco BV, Nieuwelandsraat 7, NL-7731 TH Ommen, Holland

Fotospeed,* Fiveways House, Rudloe, Corsham, Wilts, SN13 9RG

Hasselblad (UK) Limited, York House, Empire Way, Wembley, Middlesex, HA9 0QQ

Victor Hasselblad AB, S-401 23 Goteborg, Sweden

Heiland Electronic GmbH, Schulstrasse 8, D-35579 Wetzlar, Germany

Heliopan Lichtfilter-Technik GmbH, D-82166, Grafelfing

Ilford Imaging UK Limited, Town Lane, Mobberley, Knutsford, Cheshire, WA16 7JL

Keencut Limited, Unit L, Tyson Courtyard, Corby, Northamptonshire, NN18 8AZ

Kentmere Limited, Staveley, Kendal, Cumbria, LA8 9BP

Kodak UK, Kodak House, PO Box 66, Station Road, Hemel Hempstead, Herts, HP2 7EH

Maco Co., Spaldingstrasse 160a, D-20097 Hamburg, Germany

Neschen UK Limited, Emerald Way, Stone Business Park, Stone Staffordshire, ST15 0SR

Nielsen UK Limited, Unit 7, Frogmore Estate, Acton Lane, London, NW10 7NQ

Nova Darkroom Equipment, Unit 1a, Harris Road, Wedgnock Industrial Estate, Warwick, CV34 5JU

Oriental (see Maco)

Paterson, Stafford Park 1, Telford, Shropshire, TF3 3BT

Plaubel Feinmechanik u. Optik GmbH, D-60388 Frankfurt

Polaroid UK Limited, Wheathampstead House, Codicote Road, Wheathampstead, Herts, AL4 8SF

RH Designs,** Fine Darkroom Equipment, 20 Mark Road, Hemel Hempstead, Herts, HP2 7BN

Rodenstock Optische Werke AG, D-80469Munich

Seal Poducts, Hunt Graphics Europe Ltd., Basildon, Essex SS13 1BJ

Secol Limited, Thetford, Norfolk, LP24 3RR

Tetenal Limited, Tetenal House, Centuria Way, Meriden Industrial Estate, Leicester, LE3 2WH

Carl Zeiss UK Limited, PO Box 78, Woodfield Road, Welwyn Garden City, Herts, AL7 1LU

*UK agent for Amaloco products
** UK agent for Heiland products

INDEX